IMAGES
of America

CLARKSTON

Keri Jackson McFarrin

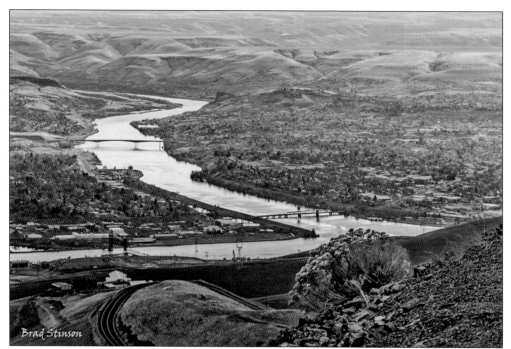

Brad Stinson

If one has ever lived in or is from the Lewis Clark Valley, there are two places that will remain indelible in one's memory—the Lewiston Hill and the Lewiston-Clarkston Bridge that connects the two cities of Lewiston, Idaho, and Clarkston, Washington. Though they are separated by a river and are in different states, the residents of both cities appear to be from one place, driving back and forth across the river to shop and work. The Lewiston Hill was designed by C.C. Van Arsdol, one of the founders of Clarkston. Van Arsdol arrived in the area in 1893. The original Spiral Highway was an eight-mile road with 60 dangerous switchbacks and drop offs. It took about a half-hour to drive it. The old highway was replaced with the Lewiston Hill Highway in 1977. It now takes about approximately five or six minutes to arrive at the top. (Courtesy of Brad Stinson.)

ON THE COVER: Describing life in the mid-20th-century southeast Washington, former Lewiston resident Betze Busch Counsell wrote: "My dad (Nick Busch) had our sheep ranch up past Asotin from 1946 to 1965. We lived in Lewiston as my mom was a teacher in Lewiston and Clarkston. On Thanksgiving every year we herded our sheep from the old Calvary barns on 16th Avenue, down Snake River Avenue, across the Clarkston bridge, along the river road up to Ackerman bar up the Snake. It was 20 miles. Many great memories, although we may not have thought that at the time. The new lambs and mommas stayed up on our grazing lands until Memorial day, then we trucked them to the St. Joe National Forest in Clarkia, etc. for the summer then sold the lambs in Moscow, Idaho in the Fall and began our trek back again!!!" (Courtesy of Nez Perce County Historical Society.)

IMAGES
of America

CLARKSTON

Jeri Jackson McGuire

ARCADIA
PUBLISHING

Published by Arcadia Publishing
Charleston, South Carolina

Printed in the United States of America

Library of Congress Control Number: 2014948582

For all general information, please contact Arcadia Publishing:
Telephone 843-853-2070
Fax 843-853-0044
E-mail sales@arcadiapublishing.com
For customer service and orders:
Toll-Free 1-888-313-2665

Visit us on the Internet at www.arcadiapublishing.com

*The book is dedicated to my husband, Jim McGuire, who cheerfully
backs me on yet another project. His help was invaluable, as is he.*

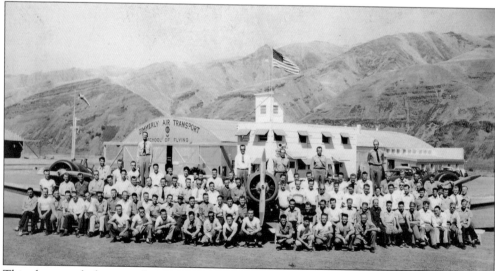

This photograph shows students training at Zimmerly Air Transport in Clarkston. This is at the
beginning of World War II. Bob Kernan Sr. is in the third row, fifth from left. He so wanted to
be a pilot in the war, but right before he could become one, the military changed the maximum
age. He was too old, but he enlisted anyway. He graduated high school in 1933, and he married
Rowena in 1939. He was a sergeant and squad leader in Europe during World War II. He received
the Purple Heart for wounds received at the Battle of the Bulge and a Bronze Star for his actions
at the Battle of Remagen Bridge. (Courtesy of Kathy Kernan.)

CONTENTS

Acknowledgments 6

Introduction 7

1. Go West, Young Man 9

2. New Bridge, Old Bridge, Blue Bridge 17

3. Irrigation Changes Everything 29

4. School Rules 51

5. Where Did the Beach Go? 79

6. Faces and Places 95

ACKNOWLEDGMENTS

I would first like to thank my husband, Jim, for helping me right up until the deadline. I would like to thank Steve Branting, who suggested that I write a book about Clarkston and pointed me in the right direction. Steve has been such a great help showing me the way down the literary path.

Special thanks go to John Vorous, Bill Lintula, and Doug Morris, whose amazing collection of historical photographs are contained in this book. I would also like to thank Linda Munson Covey for her contribution of her father, Al Munson's photographs.

Marilyn Pike Wilson was so helpful in getting photographs of the high school and also including me with a group of Clarkston residents who told me great stories of the area. I am indebted to her.

Many thanks go to Dick Riggs and Mary E. White Romero of the Nez Perce County Historical Society for their great support and the use of society's photographs. Dick also loaned me his mother's old Clarkston High School yearbooks, which I really appreciated.

A great big thank you goes to Virginia A. Sarbacher for the three beautiful professional aerial photographs of the bridges. She is the owner of V-n-R Imagery and a very talented photographer, as you will see.

I would also like to thank JoAnne Schaner Miller of the Asotin County Museum for her invaluable assistance in getting me started on my journey, and thanks to the Asotin County Museum for the use of its many photographs of Clarkston. Additional thanks go to Doug Renggli of the Clarkston Library for the use of his photographs and for his invaluable knowledge of Clarkston and its environs.

Thank you to Washington State University for its generous use of its historical photographs of the Clarkston Beach.

Special thanks to Judi Wurtze of And Books Too for all she has done to help me launch my first book.

I would also like to thank Rebecca Coffey and Matt Todd of Arcadia Publishing for all the wonderful help and assistance they have given me in getting this book published.

Lastly, I want thank my family, Jim, Ron and Teri, Matt, Herta, and Brandi McGuire, Stina and Michael Vazquez, and Marsha and Dave Smith, for all their gracious encouragement and support.

INTRODUCTION

Driving through the Washington Palouse from the north, a visitor can be startled upon reaching the crest of the famous Lewiston Spiral Highway and looking down the seven miles to the bottom. For many people, this is their first glimpse of Clarkston, Washington, and of its sister city, Lewiston, Idaho. Separated by the Snake River, Clarkston is on the west and Lewiston is on the east. They share the confluence of the Snake and Clearwater Rivers in southeast Washington. The towns are often referred to as the "twin cities," but Lewiston has always been the larger of the two sister cities, with Clarkston getting the short end of the pork chop.

The cities were named for the explorers Meriwether Lewis and William Clark, who traveled through the area in 1805 and 1806. They camped at Alpowa, about seven miles downstream from the port of Clarkston, but the men never actually stepped foot on the site of the sister cities.

With gold discoveries along the Clearwater drainage in Idaho in 1860, Lewiston became the jumping-off place for treasure-seekers scurrying for riches. Miners needed a place to stay, and Lewiston became a tent city almost overnight. It was a wild place to live.

The land that would become Clarkston attracted a few settlers. Those who wanted a more quiet life boarded the Edmund Pearcy ferry from Lewiston, which took them to the Washington side of the river. Deed records for the area reveal the names of the earliest settlers: John M. Curry, Martin Hagaman, Arthur Shaff, Henry Critchfield, and Jake Goble.

The land was hardscrabble dry sagebrush and sand. The locals called the tiny town Jawbone Flats. There are two claims as to the origin of that name. Local lore has it that, from the top of Lewiston Hill, the geography of the area resembles a jawbone. In another version, settlers thought the area would be a good place to raise cattle. After a very cold winter, a lot of the cattle died. When spring arrived, the land was strewn with many bleached jawbones.

Cassius C. Van Arsdol visited Jawbone Flats in 1893 and envisioned the dry sand as "blossoming orchards." Edgar H. Libby and Charles Francis Adams also saw promise in it. Joined by other businessmen, Van Arsdol, Libby, and Adams bought up water rights and began planning for the construction of an irrigation canal to convey water from the Asotin Creek to the flats. Van Arsdol would later design the Lewiston Spiral Highway.

Commercial yields of fruits began to materialize around 1910, and Clarkston soon became famous for its cherries, raspberries, and strawberries. The first special shipments of the new sweet bing cherry came from Clarkston. The fruit won many prizes at fairs wherever it was shown in the area.

On August 24, 1898, a permit was issued to build a bridge across the Snake River connecting Idaho and Washington. The span had been intended for a location in Argentina, but that order had been canceled. With an extension on the east end, it was made to fit the Snake River location. Built at a total cost of $110,000 ($3.1 million today), the bridge opened for use on June 24, 1899.

Finnish people moved to Clarkston in the early 1900s and again in the early 1930s. They owned many orchard tracts in the Heights. Names like Rantala, Lintula, Ruotsala, Neimi, Koskil, Lumona, Lahti, and Santa became familiar.

By 1897, after being called Jawbone Flats and Lewiston, the town became known as Concord, a name that reminded Libby and Adams of their Massachusetts roots. The *Clarkston Herald* reported, "Frank Morrison, who lived in Concord wanted to buy a house in town. Mrs. Morrison said, 'Not as long as it is named Concord.'" Acting on a local petition, the US Post Office was officially renamed Clarkston on January 1, 1900, and the town was incorporated on August 4, 1902, nearly 50 years after Lewiston was incorporated.

Clarkston's public school system dates from 1897, starting in a small room in a private home. The first school building was erected in 1898 at the corner of Thirteenth and Chestnut Streets. It was destroyed by fire in 1899, reportedly by a vagrant, and was replaced by Whittier School in 1901. In 1906, it became the Longfellow Building, which burned down in 1921. A new high school was completed in 1923 and named in honor of Charles Francis Adams (1835–1915), the Boston financier whose efforts led to the early development of the community.

Holy Family Catholic School opened on September 6, 1921, with the building of the first Holy Family Church. The first five students graduated from the new school in May 1922. Prior to that, students from Clarkston were sent to Lewiston's St. Stanislaus School.

Streetcars came to Clarkston on May 1, 1915. It was an exciting day for the people of both towns. However, the high arch of the new cantilever bridge caused traction problems on the steep grade. The only way to resolve the problem was to have a wheelbarrow precede the streetcar scattering sand. This solution probably diminished some of the glamour of the occasion.

The Clarkston beach began in 1921. It was favored with a natural jetty of rock extending into the river just east of town. The sand extended clear to the river, and the swimming area was clear of rocks. There was a beach house with electric lights, running water, and dressing rooms. It was destroyed when the slack water arrived.

On August 16, 1936, the Asotin County Courthouse, at Asotin, five miles south of Clarkston, burned to the ground in an act that was determined to be arson. People speculated that the fire was a "Clarkston job," as there had been many attempts to have the county offices moved to Clarkston. This story was never proven.

In 1939, a new bridge began to rise beside the old one to the north. The alignment of the new interstate bridge had an effect on Clarkston's streets. The old bridge had been aligned with Bridge Street. That was no longer the case. The new bridge required the building of a new road with a curve that would join Bridge Street at Clarkston's Second Street. The construction of the bridge spurred the development of Bridge Street as an arterial.

Clarkston's first cemetery, Lewis and Clark Memorial Park, was short-lived. A 10-acre site was developed on Bridge Street, and plots were prepared for 134 people. Then, hard times hit, and all 15 of the bodies interred there were removed. The site was completely relandscaped. Today, it is located near the No. 3 tee and fairway, the No. 2 green, and part of the No. 2 fairway of the present Clarkston Golf & Country Club.

Clarkston's public image received a well-deserved boost in 1976, when a local high school student, Lenne Jo Hallgren, won the national America's Junior Miss Competition.

Riverboats, popular from 1861 to 1940, have come full circle with the dams and the resulting pools, making Lewiston "Idaho's Only Seaport." Clarkston also has ports. Stern-wheelers have made a return to Clarkston and Lewiston. By 1994, even larger vessels brought tourists upriver from Astoria, Oregon, to both cities.

The two communities have always been close, not just geographically but also in terms of friendliness. The only real longtime rivalry between the towns has involved their high school football teams. They have played each other since 1906 for bragging rights in what was for many a Thanksgiving Day highlight.

One

GO WEST, YOUNG MAN

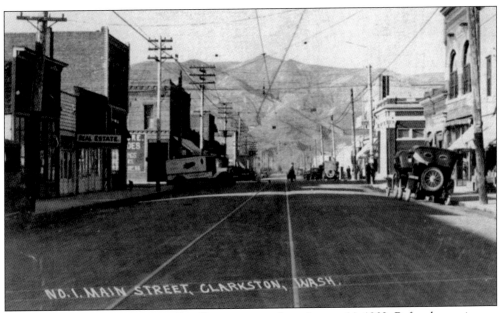

Clarkston, settled in 1862, was officially incorporated on August 14, 1902. Before becoming an official town, it was called Jawbone Flats. An article in the *Clarkston Republican* newspaper on January 5, 1901, says, "Jawbone is also a western phrase meaning 'without means.'" That was very true of the founders, who found nothing but sand and sagebrush when they arrived. They dreamed that it would become the perfect place to grow lush crops and flowers. The *Clarkston Republican* wrote on February 7, 1903: "What is now a large area of happy homes, in 1897 was a desert waste, the range of the coyote and jack rabbit was disrespectfully known as 'Jawbone Flat.'" The area would later be called Clarkston and Vineland, but not before it went through a couple more name changes. This photograph was taken around 1920. It is of Main Street, also known a Sixth Street, and shows the trolley tracks between Chestnut and Sycamore Streets. (Courtesy of Asotin County Museum.)

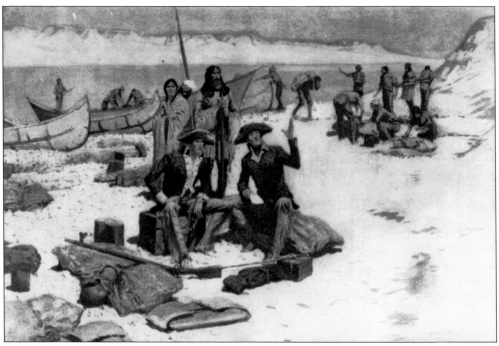

Even though Lewiston and Clarkston take their names from the famous explorers, Lewis and Clark, they never set foot on the land, only skirted it. The explorers were friendly with the Indians and would visit them often at Alpowa, their home near Silcott, a few miles west of the area. (Courtesy of Library of Congress.)

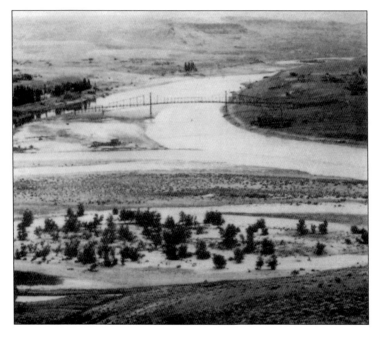

Clarkston, Washington, and Lewiston, Idaho, are twin cities that meet at the confluence of the Snake and Clearwater Rivers in southeast Washington. Gold was discovered near Pierce, Idaho, in 1861. This brought settlers, who crossed the Snake River to an area called Jawbone Flats because of its flat topography and prevalent sagebrush. (Courtesy of Asotin County Museum.)

The confluence of the Snake River and the Clearwater River outlines the flat on the east and north, in an irregular bend that early cattlemen evidently thought resembled a jawbone. The name "Jawbone Flats" may also have derived from the deaths of many cattle following a very cold winter. When spring arrived, the ranchers discovered a lot of bones on the land. (Courtesy of Asotin County Museum.)

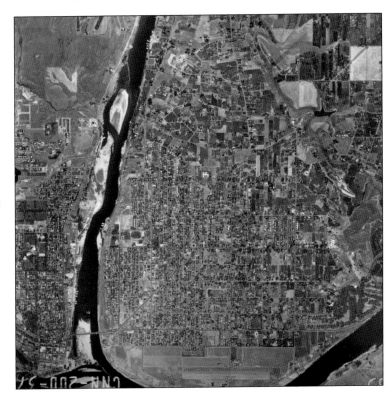

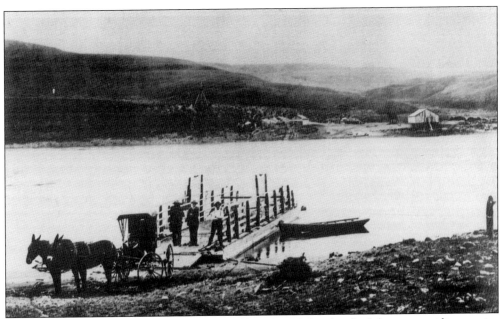

This is an early photograph of the ferry owned by John W. Smith, which began providing service to Clarkston, Washington, in 1856. The men in the photograph, probably taken in the mid- to late 1800s, are not identified. The ferry was the only way to get to Lewiston, Idaho. (Courtesy of Doug Renggli.)

After the bitter winter, the settlers left. Only those settlers who had used their homestead rights and kept some livestock stayed on, hoping that, eventually, someone would buy them out. Some turned to stock, raising cattle, sheep, or horses. This was better, as grass was plentiful for food and their livestock could be driven to market. (Courtesy of Asotin County Museum.)

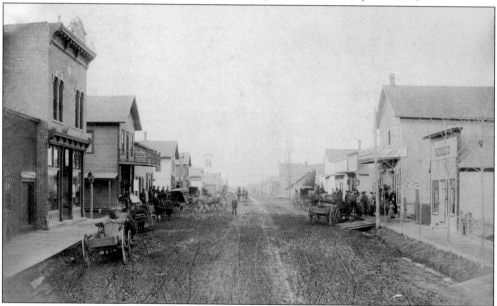

In 1899, more than $100,000 in new commercial buildings were built on the flat that would become Clarkston. Only a few of Clarkston's earliest businesses remain. Some of the old Western brick buildings are still standing, but the farms and orchards are no longer there. (Courtesy of Asotin County Museum.)

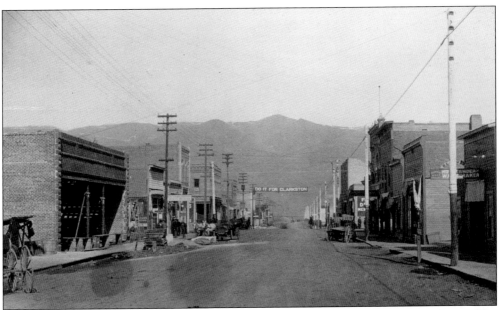

Sixth Street was Clarkston's early main thoroughfare. This was also known as Main Street. The Brandford Hall building shown here was soon taken over by Henry R. Merchant. It would later become Boyer's Furniture, one of Clarkston's most popular stores. Another store, in the forefront, was a small shoe shop whose name is long forgotten. This picture was taken around 1905. (Courtesy of Asotin County Museum.)

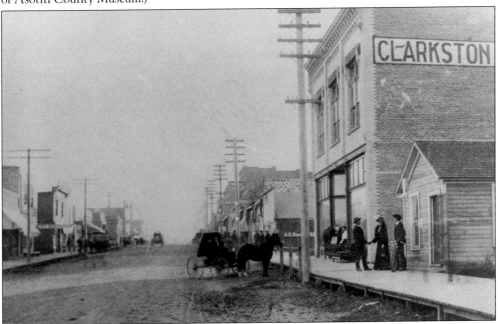

Before Clarkston became the official name on August 4, 1902, it was anyone's guess what the river city would be called. Some wanted to name it Lewiston, but the postmaster nixed that plan. It was called Concord for some time, but that name was not well received. Giving a nod to the explorers Lewis and Clark, the people decided to name the town Clarkston. (Courtesy of Asotin County Museum.)

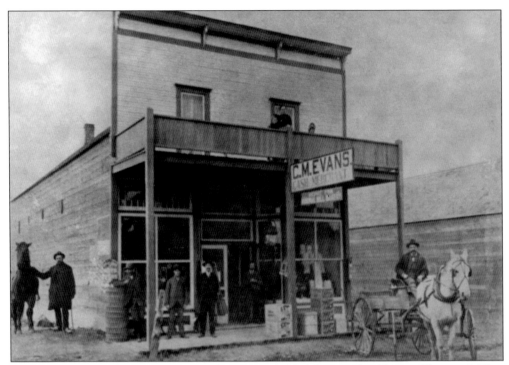

The Evans Mercantile Company is seen here in 1912. Neil Stewart, bookkeeper Florence Miller, and clerks Ernest Ruberg and Albion Carlson were the employees. Despite the flat's dreary aspect, some settlers saw possibilities in making their homes there. One hardship was the fact that residents could not get water for their livestock without hauling it over the rocky river. (Courtesy of Asotin County Museum.)

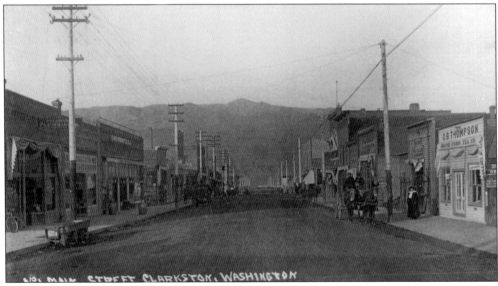

In 1896, the first grocery store, at 902 Sixth Street, began selling groceries, tobacco, and candles. Sixth Street was designated "Main Street" when the Lewiston Water and Power Company office went up on the east side of Sixth Street, even though the city plat had named it Diagonal Street. (Courtesy of Asotin County Museum.)

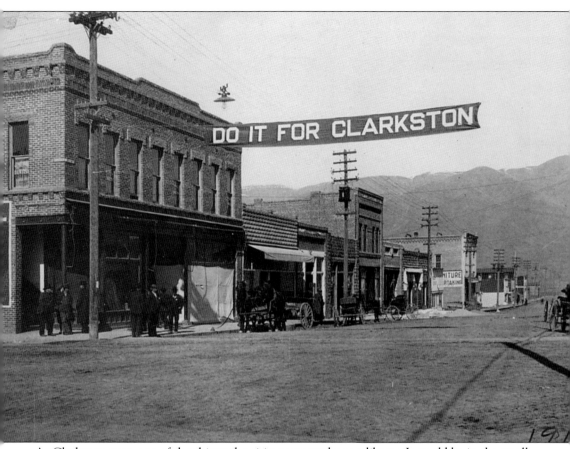

As Clarkston grew, one of the things the citizens wanted was a library. It would be in the small white building at the end of the street. The "Do It For Clarkston" banner was encouraging residents to donate books and money to the cause. (Courtesy of Asotin County Museum.)

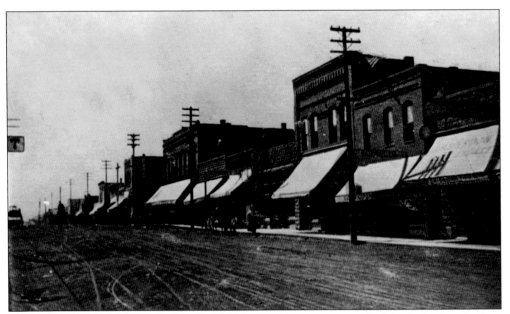

During Clarkston's infancy, business started booming as pipes were laid for irrigation ditches. Businesses and homes went up, and scores of orchards were planted. Plans were made for a new bridge and more. Money spent would be the equivalent to almost $2 million today. (Courtesy of Asotin County Museum.)

The Uniontown Grade is seen here in 1910. It was surveyed and built by John Silcott in 1872–1874. Not many people were aware that a road existed before the Lewiston Spiral Highway. A wagon road, the grade was the only route up the Lewiston Hill for over 43 years. (Courtesy of Nez Perce County Historical Society.)

Two

New Bridge,
Old Bridge, Blue Bridge

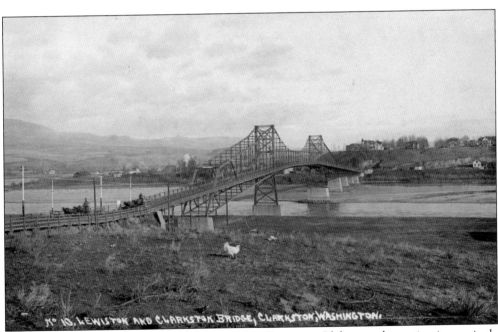

At the end of the 19th century, gaining access to Lewiston, Idaho, was becoming increasingly important to Clarkston. In 1896, Edgar H. Libby received the original franchise to build a bridge over the Snake River. He and the city leaders worked to make it happen. (Courtesy of Asotin County Museum.)

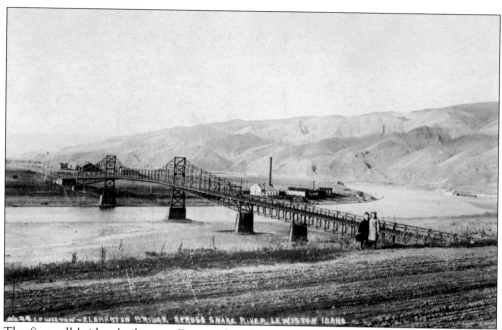

The first toll bridge, built at an Eastern foundry, was originally intended to span a river in Argentina, but the South American firm canceled the order. Following an extension on the east end, the structure fit the beautiful Snake River location. The total cost was $110,000. (Courtesy of Asotin County Museum.)

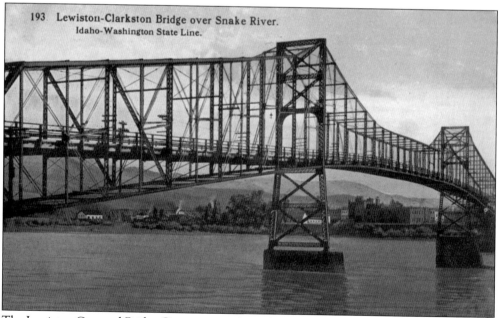

The Lewiston Concord Bridge Company was formed to build a toll bridge that would carry foot and wagon traffic and other important items. This span would change the course of the residents' lives. They no longer had to depend on ferries. It was opened on June 24, 1899. (Courtesy of Asotin County Museum.)

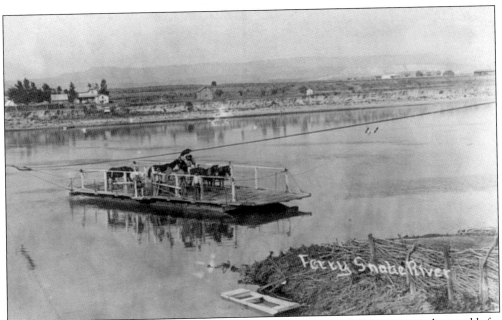

This ferry is seen from Clarkston. Note the early homes on Normal Hill. Ferries were indispensable for getting settlers across the river. Fees ranged from 10¢ for sheep or hogs to $1 for a man and horse and up to $4 for a wagon and a pair of horses. (Courtesy of Nez Perce County Historical Society.)

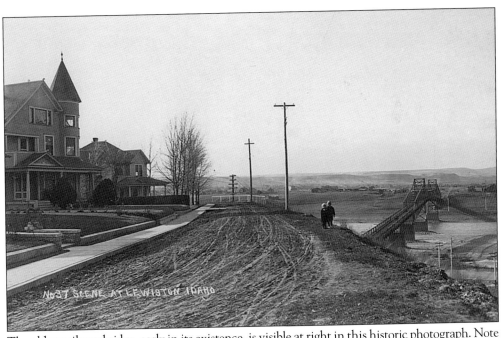

The old cantilever bridge, early in its existence, is visible at right in this historic photograph. Note the unpaved roads and the walk down to the bridge. When this bridge was replaced, the new drawbridge was placed right next to it. This was a prosperous time for Lewiston and Clarkston. (Courtesy of Asotin County Museum.)

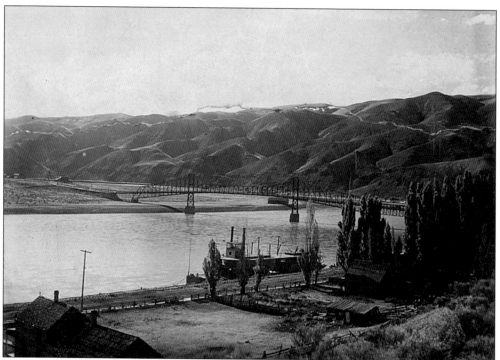

The cantilever bridge is seen here from Lewiston. Clarkston can be seen in the distance. The Lewiston-Clarkston toll bridge was the largest wagon bridge in Washington. In 1913, the span was sold to the public, with both states maintaining it as a toll-free bridge. (Courtesy of Asotin County Museum.)

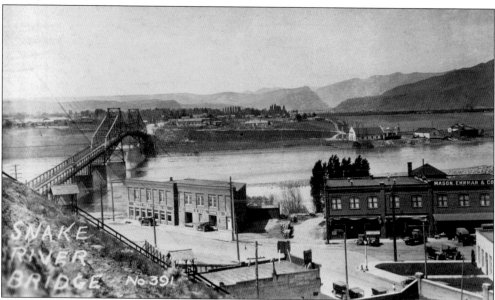

This is another view of the new Concord-Lewiston bridge from the Lewiston side of the river. The bridge, which officially opened with ceremonies on July 4, 1899, was the first interstate span. The toll bridge charged 5¢ for pedestrians and 10¢ for wagons. (Courtesy of Asotin County Museum.)

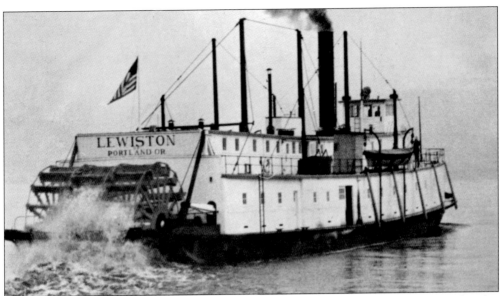

Steam wheelers were able to pass under the bridge, carrying passengers up the Snake River. This made shipping easier and brought more goods and people into the area. This was one of the last steam wheelers to pass under the bridge as other modes of transportation appeared. (Courtesy of the Asotin County Museum.)

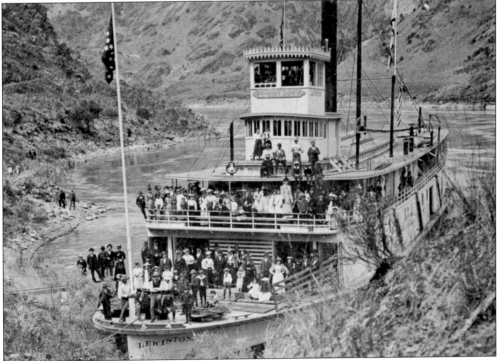

The steam wheeler *Lewiston* would take people on excursions. Passengers sometimes brought lunches for a picnic on shore, and some would make a pot luck dinner. It was destroyed by fire and was replaced with a cargo ship also called *Lewiston*. (Courtesy of the Nez Perce County Historical Society.)

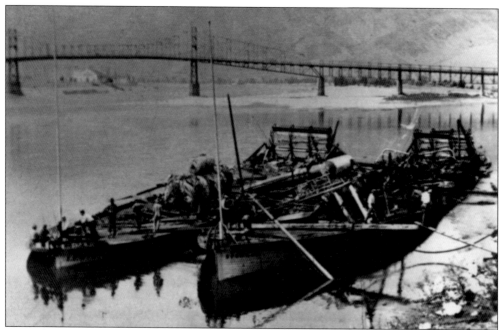

The steam wheelers *Lewiston* and *Spokane* are seen here after they were destroyed by fire in 1922. The replacement vessel, also called *Lewiston*, was built exclusively to haul cargo. Prior to that, some of the vessels boasted quite elegant staterooms and dining rooms. They helped keep the communities alive throughout eight decades. (Courtesy of Doug Renggli.)

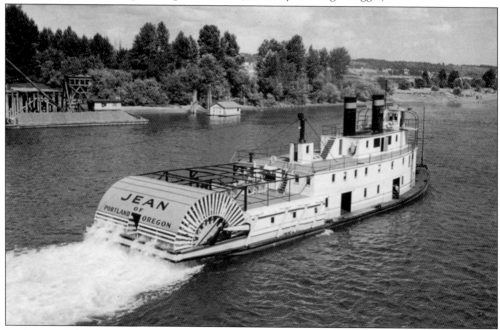

In August 1989, the stern-wheeler *Jean* was operating on the Snake River, having been there since 1976. Her location changed from time to time, and Hells Gate State Park was among the many locations where *Jean* was moored. This photograph was taken in 1980. (Courtesy of Bill Lintula.)

This photograph shows the new interstate bridge, dedicated in May 1939. The bridge spans the Snake River between Lewiston, Idaho and Clarkston, Washington, and is known as the Blue Bridge. This photograph was taken from the Lewiston side of the river looking west towards Clarkston. (Courtesy of Doug Renggli.)

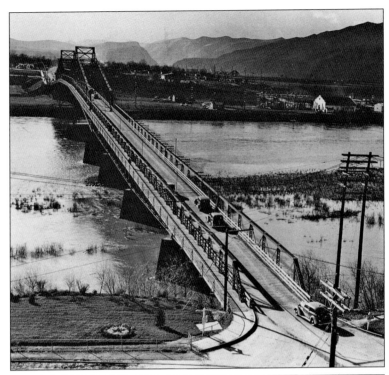

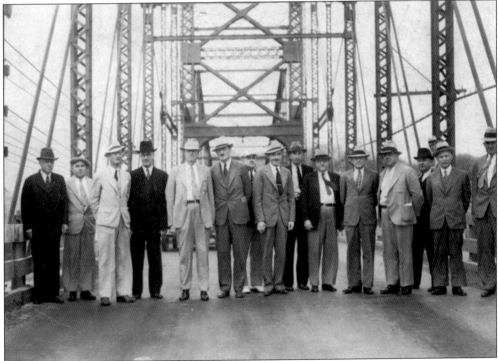

This new bridge, built to replace the old toll bridge, was necessary with the prevalence of steam wheelers. In the 1930s, John Vorous's great-grandfather Albert C. Vorous was mayor of Clarkston. He is seen here on the far left; the others are city leaders. (Courtesy of John Vorous.)

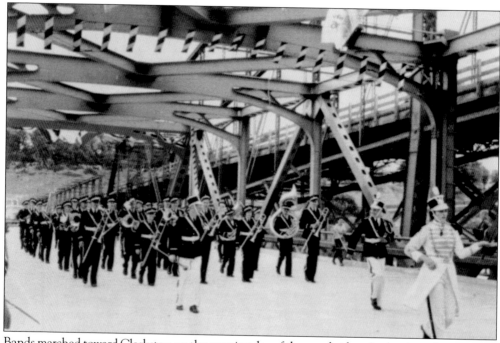

Bands marched toward Clarkston on the opening day of the new bridge. At the time, the new span cost $750,000. It replaced the old cantilever bridge that had stood since 1899. It was an exciting day for one and all. (Courtesy of Nez Perce County Historical Society).

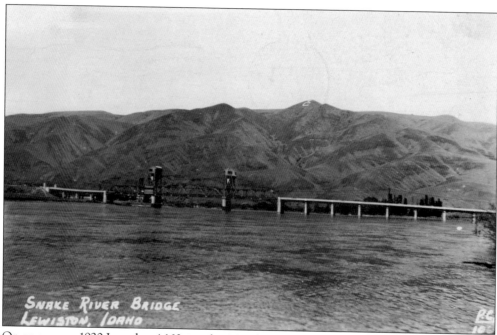

On an average 1920 June day, 4,160 people, 1,007 horses, and 331 automobiles crossed the Snake River on the Lewiston-Clarkston Bridge, according to Clarkston police officer L.R. Lommasson. The Snake River is a major waterway of the greater Pacific Northwest in the United States. (Courtesy of Asotin County Museum.)

In 1947, Vernon L. Snook sits on the Clarkston side of the new Lewiston-Clarkston Bridge. People called him "Brownie." When the new drawbridge was built, it was painted green. It would later be painted blue and then referred to as the "Blue Bridge." (Courtesy of Jane Harrington.)

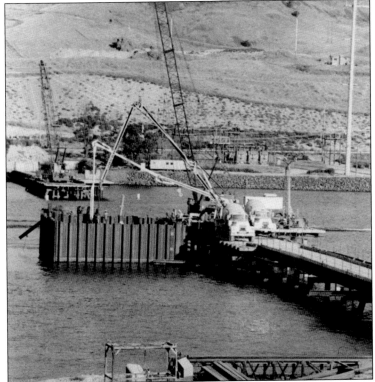

Southway Bridge is shown in the process of being built across the Snake River. It would provide easier access to Clarkston, Lewiston, and Asotin for travelers. It connects on the Lewiston side to the new Bryden Bypass and to Snake River Avenue. (Courtesy of Doug Renggli.)

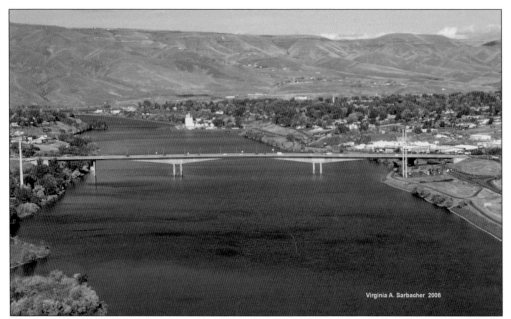

The finished Southway Bridge spans the Snake River. A major river in this part of the Pacific Northwest, the Snake River is 1,078 miles long. It is the largest tributary of the Columbia River, which is the largest North American river that empties into the Pacific Ocean. (Courtesy of Virginia A. Sarbacher, V-n-R Imagery.)

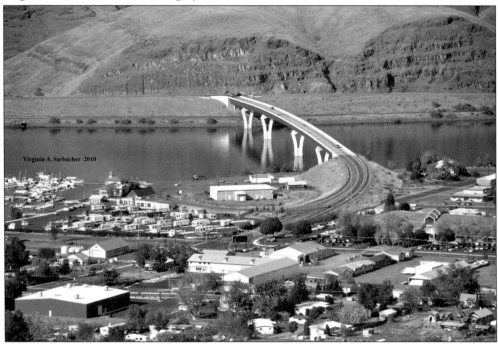

The Red Wolf Crossing Bridge was dedicated on October 19, 1979. For years, it was called the "Someday Bridge." Its construction was not completed until the new dams went in for future levees. Drivers no longer have to go through Lewiston streets to arrive at Clarkston. (Courtesy of Virginia A. Sarbacher, V-n-R Imagery.)

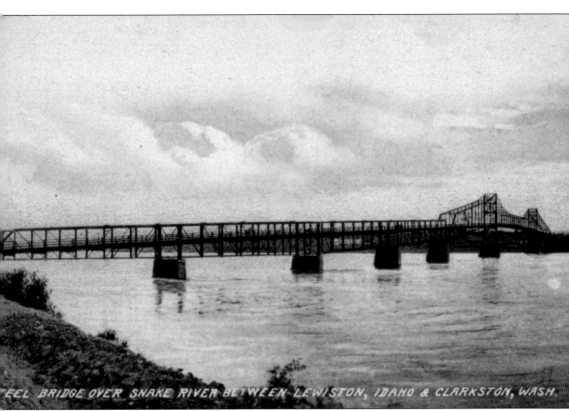

EEL BRIDGE OVER SNAKE RIVER BETWEEN LEWISTON, IDAHO & CLARKSTON, WASH.

The Lewiston-Clarkston Bridge was the first bridge to span the Snake River between Washington and Idaho. On June 24, 1899, it opened for traffic. The 1,700-foot-long bridge connected Clarkston, Washington, and Lewiston, Idaho. The span was a toll bridge; fees were 5¢ to cross on foot and 10¢ by wagon. (Author's collection.)

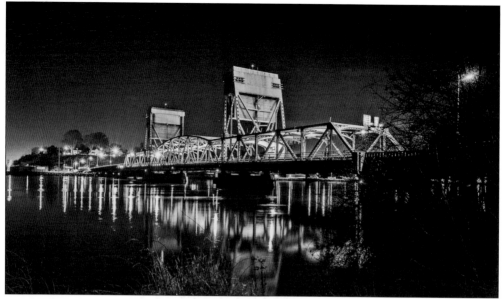

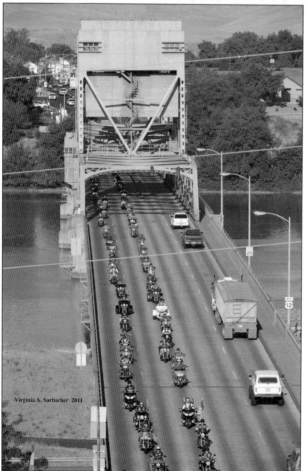

Virginia A. Sarbacher 2011

This is a modern day photograph of the Lewiston-Clarkston bridge, which connects Clarkston with Lewiston. The bridge is one of the first memories one had growing up in these towns. This photograph was taken at night by Marcia Darby, who loves the reflections from the lights on the bridge in the water. She likes that they are almost magical. (courtesy of Marcia Darby.)

This is a great photograph of the Lewiston-Clarkston Bridge taken from overhead. The Patriot Guard Riders had been requested to participate in the escort of the Vietnam Tribute Wall from Clarkston, Washington, to Lewiston, Idaho, to the Nez Perce County Fairgrounds and to stand a flag line at the opening ceremonies. The Escort Mission was scheduled for August 11, 2011, at 8:00 a.m., which they attended. The Patriot Guard Riders also had a flag line that same evening at 7:00 p.m. for the opening ceremonies and were a part of that ceremony. (Courtesy Virginia A. Sarbacher, V-n-R Imagery.)

Three

IRRIGATION CHANGES EVERYTHING

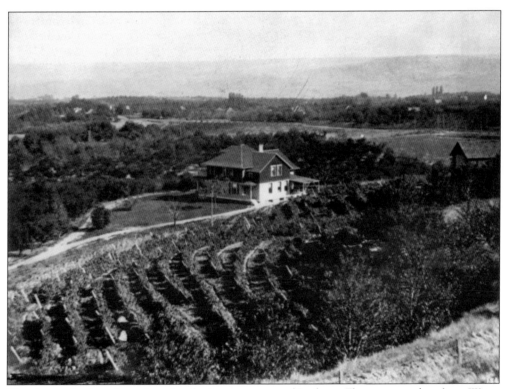

Thanks to the founders, plans for the improvement of Jawbone Flats were undertaken. Water rights were bought, and building commenced on an irrigation canal to convey water from the Asotin Creek to the flats. The barren land became lush with orchards and gardens. (Courtesy of Asotin County Museum.)

This is believed to be the advance logistics team for the future Clarkston-Vineland water canal. It brought one or two pieces of heavy equipment and packed a load of mattresses and tents to the "head gates." It took more than a year to dig the ditch, which followed the contour of the hills. (Courtesy of Asotin County Museum.)

The first road around Swallows Nest looked like this in 1900. According to Bill Lintula, his grandfather Frank Lintula had a great deal to do with the building of this huge pipeline. Horses and wagons were invaluable. That old water pipeline from Asotin Creek helped to build Clarkston. (Courtesy of John Vorous.)

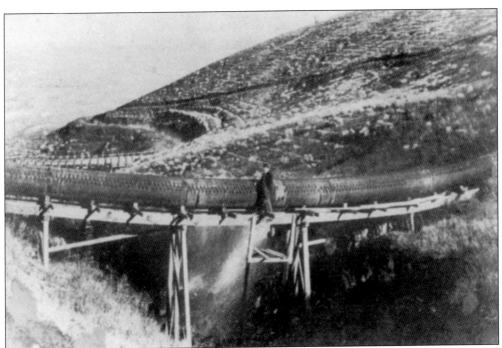

Drinking water was obtained by diverting the flow into a small flume, then through a filter of white sand or charcoal and into concrete cisterns. Filling the cistern was a seasonal project that had to be completed in the spring or fall, when the water was running cool in the open ditch. (Courtesy of John Vorous.)

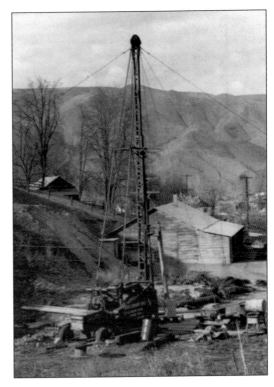

A new well is being dug at Fifteenth Street and Sixteenth Avenue. Ditch-digging took more than a year and followed the contour of the hills. The first water supply in 1896 was unreliable, but by 1899, all of Clarkston's 25 homes were served by the water from an open ditch. (Courtesy of Asotin County Museum.)

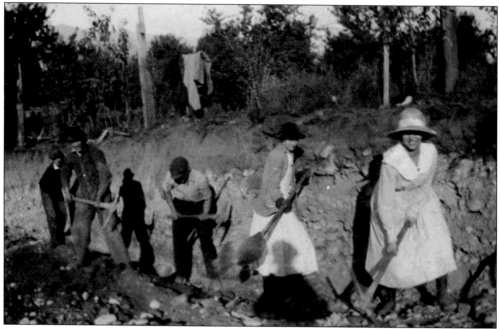

Everyone, including the women, participated in digging the ditch for the water. The project made possible the transformation of the sandy, sage-covered stretches of Jawbone Flats into blossoming orchards with fruit and flowers. Asotin Creek was doing all it could. The orchards, raspberries, strawberries, and vegetables flourished. (Courtesy of John Vorous.)

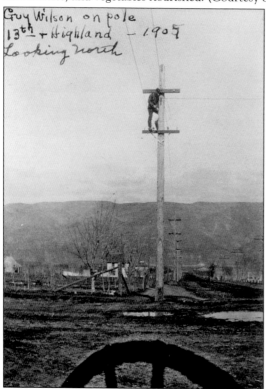

In this south-facing photograph, Vic and Slim Robinson are on the pole, and Norman Allen is on the ground. To the left of the pole, Guy Wilson is in his rig with his wife, Maybella. Leroy Brown is in the buggy. This was at Thirteenth Street and Highland Drive in 1905. (Courtesy of Asotin County Museum.)

Clairsy Nordly was about 15 years old in 1928–1929, when this photograph was taken. She was the niece of Doug Morris's grandmother Grace Way. Her family owned acreage on the upper Asotin Road and lived for some time on Sixteenth Avenue. (Courtesy of Doug Morris.)

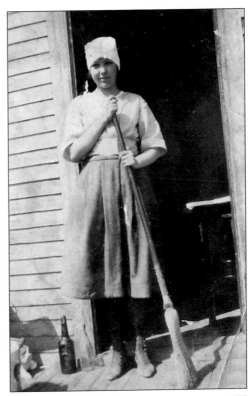

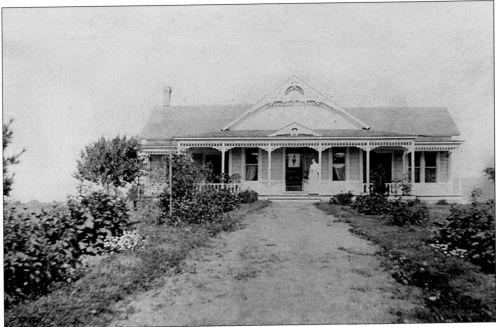

When pioneers arrived, they needed to build homes in the Clarkston area. "Pioneer Homes of Jawbone Flats" dated some houses back to Clarkston's beginning days. The National Register of Historic Places has an office near the intersection of Fifteenth and Chestnut Streets in Clarkston, where the homes are listed. (Courtesy of Asotin County Museum.)

Cousins Doug Morris and Dianne Tippett play in the yard of their grandparents Kyle and Grace Way. The home is on the Old Pomeroy Road, which Sixteenth Avenue was called at the time. Their mothers were Norma and Patricia Way, who married war buddies Jerry Morris and Ed Tippett, respectively. (Courtesy of Doug Morris.)

Doug Morris writes that Kyle and Grace Way (pictured) were his grandparents. They moved to Clarkston in 1924 and had five children: Eldred, who died at age 17; Tom, who owned Clarkston Heights Market; Norma; Reid, who was killed on Omaha Beach in World War II; and Patricia, who worked at Wasems for many years. (Courtesy of Doug Morris.)

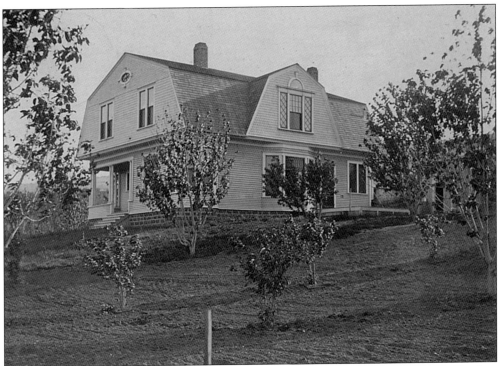

A beautiful home was built at Thirteenth Street and Peaslee Avenue in the Clarkston Heights. By 1899, Clarkston was transformed from a desert to a lush place to live because of irrigation. More and more people moved to Clarkston, and all 25 of Clarkston's homes had water. (Courtesy of Asotin County Museum.)

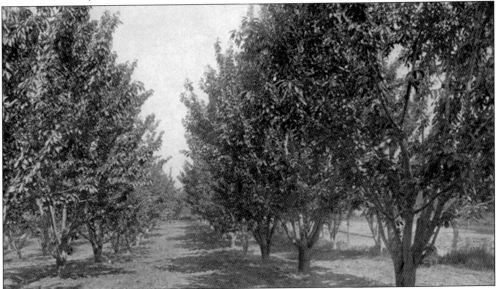

Shown here in 1911 are the 12-year-old Clarkston Heights Vineland Orchards. These orchards extended from Swallows Nest to Bridge Street. The first carload of the new bing cherry was shipped from Clarkston. The orchards shipped to almost anywhere in the United States. (Courtesy of Asotin County Museum.)

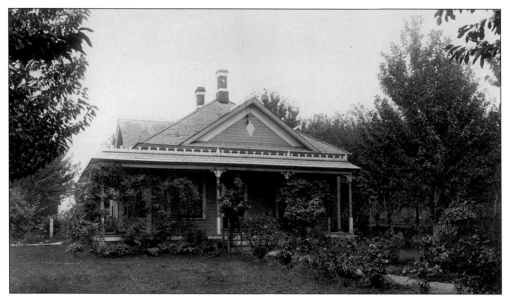

This home is on Highland Drive. Frances Justice Clausen may have lived in this house. Life changed when the settlers constructed the 14-mile canal. The water irrigated Asotin and the present-day Clarkston area, turning the dry flats into a thriving community that soon became populated with many people. (Courtesy of Asotin County Museum.)

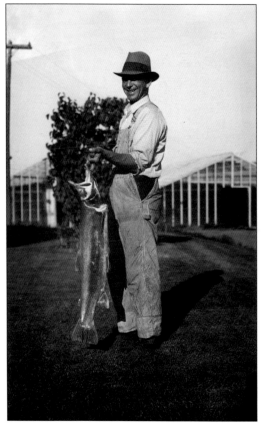

John Vorous found this wonderful photograph of a man holding what looks like a record-breaking steelhead. The man was a friend of his grandfather's. It is assumed that the fish was caught in the Snake River; at that time, the fish were much bigger. (Courtesy of John Vorous.)

Bill Lintula's Finnish family poses in the Clarkston Heights. Shown here are, from left to right, John Suomi (Bill's grandmother Lusiina Lintula's second husband), Bill's cousin Deanna Kumpula, his brother Lyle, his grandma (holding Bill), and his sister Bette. (Courtesy of Bill Lintula.)

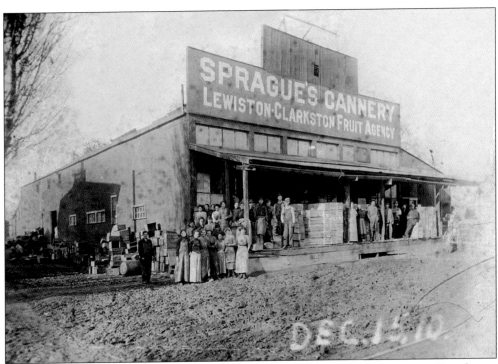

Sprague's Cannery was one of the numerous fruit produce businesses downtown on First Street. Among those pictured with the unidentified on the porch are Lettie Whitesel and Sarah Boughton. There were numerous canneries in both Lewiston and Clarkston to process the fruit for market. (Courtesy of Asotin County Museum.)

Clarkston's canneries were necessary for the produce that was being grown. Canneries were located at Dustin's Orchards on First Street between Bridge and Fair Streets, and there were numerous others such as this old fruit cannery on Second Street in Clarkston. There were canneries in Lewiston, too. (Courtesy of Asotin County Museum.)

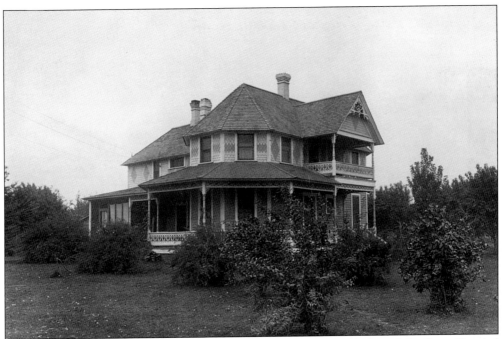

This is Dr. Shaff's home at Twelfth Street and Highland Avenue. Clarkston's Tri-State Hospital now owns the property, and the house is no longer there. In 1916, the White Hospital in Lewiston played a part in the medical care of the residents of both Lewiston and Clarkston. (Courtesy of Asotin County Museum.)

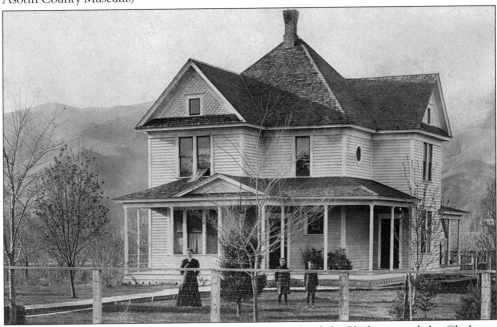

Many beautiful homes, such as this large one, were built while Clarkston and the Clarkston Heights were growing. Larger homes were necessary, as families were big. Parents needed more children to assist in working their land. Everyone in the family was expected to provide labor. (Courtesy of Asotin County Museum.)

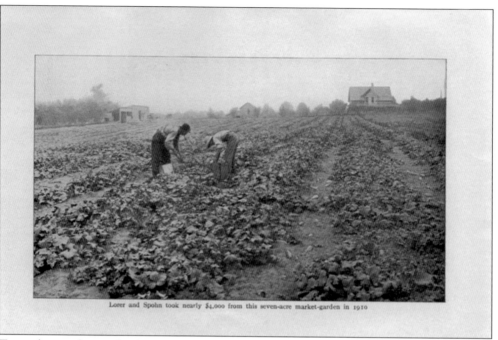

Lorer and Spohn took nearly $4,000 from this seven-acre market-garden in 1910

Two unknown farmers by the name of Mr. Lorer and Mr. Spohn earned nearly $4,000 from this seven-acre market garden in 1910. They took advantage of the Clarkston-Vineland Water Canal to enable them to grow abundant crops. The $4,000 profit would be around $96,000 in today's dollars. (Courtesy of Asotin County Museum.)

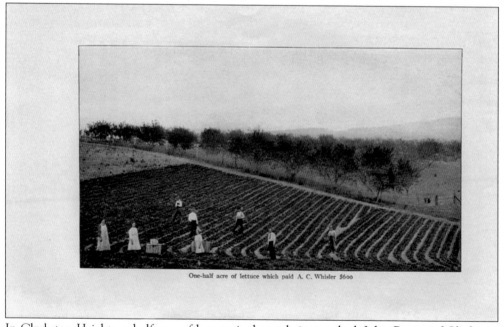

One-half acre of lettuce which paid A. C. Whisler $600

In Clarkston Heights, a half-acre of lettuce is shown being worked. John Brown of Clarkston had harvested a quarter of an acre, which amounted to 160 crates of cantaloupes. He marketed them for $2 a crate. His total production of the acre was 7,200 melons. (Courtesy of Asotin County Museum.)

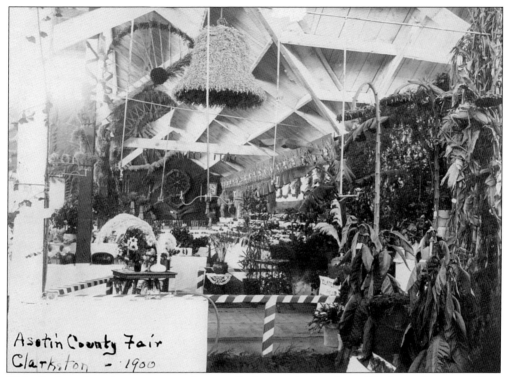

Asotin County Fair
Clarkston - 1900

This display of produce was one of many displays at the Lewiston-Clarkston Interstate Fair, held north of Clarkston until 1912. Selling an abundance of produce at the fair was a cause of celebration for the farmers, who worked so hard all year getting their crops to market. (Courtesy of Asotin County Museum.)

Doug Morris's grandmother, Grace Way, center, was the president of the local War Mothers Chapter in the mid-1950s. She lost her son Reid on D-Day, and she was a Gold Star Mother who served as the Washington State president of the Women's Veterans Auxiliary for several years. She lived in the Clarkston Heights. (Courtesy of Doug Morris.)

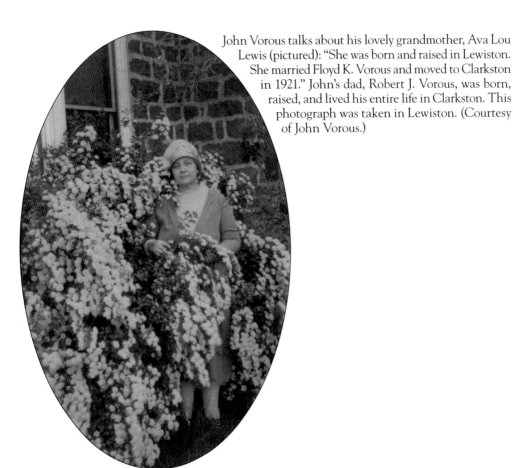

John Vorous talks about his lovely grandmother, Ava Lou Lewis (pictured): "She was born and raised in Lewiston. She married Floyd K. Vorous and moved to Clarkston in 1921." John's dad, Robert J. Vorous, was born, raised, and lived his entire life in Clarkston. This photograph was taken in Lewiston. (Courtesy of John Vorous.)

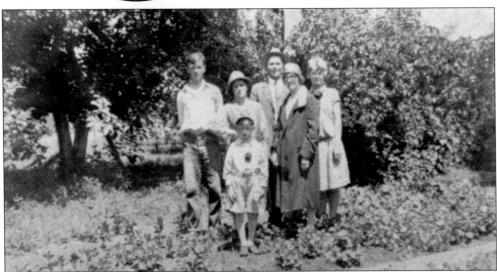

Bill Lintula's family are, from left to right, (first row) Leonard Lahti, Mrs. Lahti, and his aunt Aina Lintula; (second row) his dad Bill Lintula, his grandmother Lusiina Lintula, and Mr. Lahti. The Lystilas and the Lintulas were the first two families to arrive on the Heights in 1913. Bill's dad was one at the time. (Courtesy of Bill Lintula.)

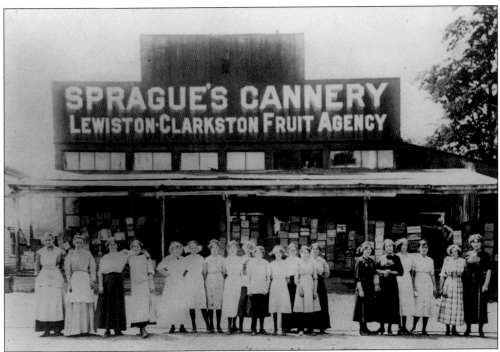

People display abundant fruits and vegetables at Sprague's Cannery. Its commercial yield of apples and cherries started around 1910. Most Lewiston canneries were located along First Street and Snake River Avenue. Clarkston's canneries were located at Dustin's Orchard, on First Street between Bridge and Fair Streets. (Courtesy of Asotin County Museum.)

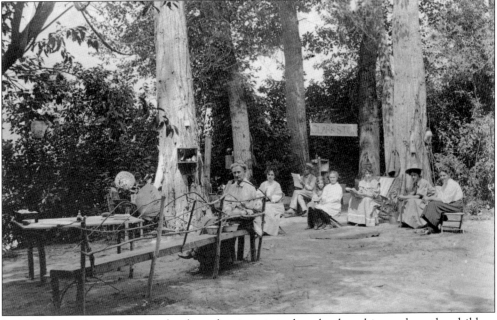

In 1908, since there were no schools at the time, it is thought that this was how the children received their education. It was a chance to be outdoors and enjoy the coolness under the trees, which protected them from the hot summer sun. (Courtesy of Asotin County Museum.)

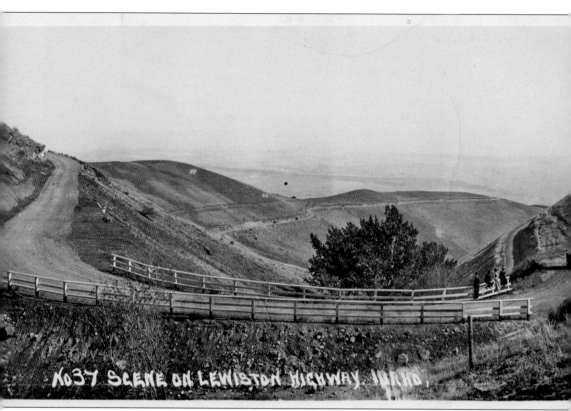

No37 SCENE ON LEWISTON HIGHWAY. IDAHO.

This photograph shows the old Lewiston Highway. Notice the people sitting on the fence. The road appears to be made of dirt. It looks like a long, dusty, and hot ride to the top. The road was designed by C. Van Arsdol, one of the first promoters of Clarkston, Washington. (Courtesy of John Vorous.)

This photograph shows Bill Lintula's brother Lyle (left) and his sister Bette (middle). The other children are unidentified. With so many families in the area, there were always a lot of children to play games and ride bikes. The picture was taken around 1943–1944. (Courtesy of Bill Lintula).

This photograph of a woman holding huge antlers is another of John Vorous's mysterious, unidentified images. The antlers are so large that there must be a fascinating story behind them. Women settlers were strong, often doing chores into their 80s. If anyone knows the circumstances of this image, please contact John Vorous. (Courtesy of John Vorous.)

This mid-1950s photograph was taken on Pound Lane in south Clarkston, west of upper Asotin Road (Thirteenth Street). Shown here are members of three neighborhood families: Morris, Wilson, and Crumpacker. They are, from left to right, Keith Crumpacker, Paula Wilson, Bruce Crumpacker, Janet Morris, Susan Wilson, and Steve Aikens. (Courtesy of Doug Morris.)

Bill Lintula's father, Bill, holds his older sister Bette Lintula (Paris) in an apple harvest bag. She seems to be enjoying the ride. Apple bags were a common sight in the orchards at that time. The harvests were large, and everyone helped. (Courtesy of Bill Lintula.)

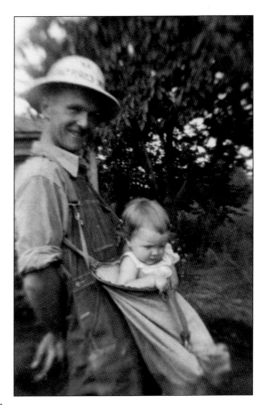

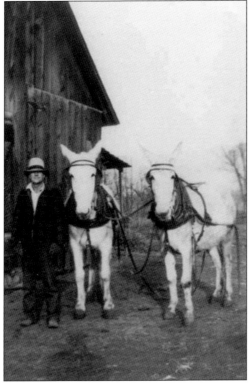

Kyle Way, Doug Morris's grandfather, shows off his team of white mules, Gyp and Jewel. This was at their property on what was then called the "Old Pomeroy Road," now Sixteenth Avenue. In 1947, Way used these mules to dig out the basement before building his house on Pound Lane. (Courtesy of Doug Morris.)

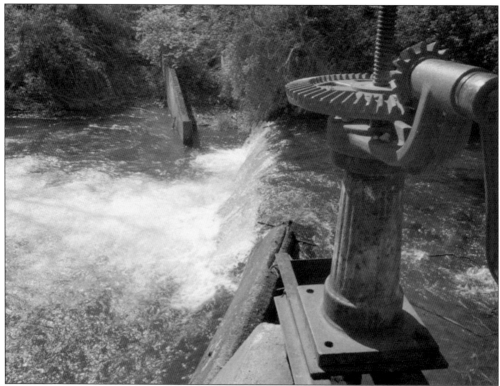

This is a head gate from the irrigation system near Asotin. An unidentified lady commented: "Asotin Creek was doing all it could. The orchards, raspberries, strawberries, vegetables loved it. People were thrilled that they had started drilling wells, however she was too young to remember the ditch digging." (Courtesy of John Vorous.)

This is the pumping station for the Heights water system. It was on the road going from Asotin up Asotin Creek. The water came from the Head Gates Dam, several miles up Asotin Creek. This structure is part of an old irrigation station along the road to Asotin. (Courtesy of Bill Lintula.)

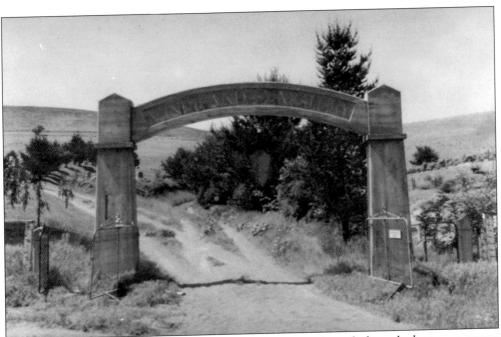

The pretty Vineland Cemetery was a sight to behold. Coming through the arched gate, one person said that "a feeling of awe almost overcame her because the sight was so beautiful." Cemetery developers braved threats of lynching from angry objectors and eventually built this beautiful cemetery. (Courtesy of Asotin Country Library.)

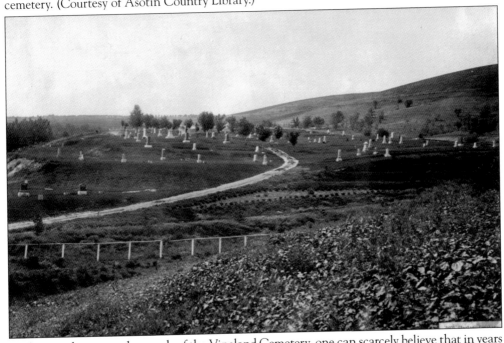

Looking at the terraced grounds of the Vineland Cemetery, one can scarcely believe that in years gone by, when the city was called Concord, the cemetery grounds were rough, gopher-infested land covered with sagebrush. A threatened lynching was narrowly averted in order that the present beauty might be attained. (Courtesy of Asotin County Museum.)

Bill Lintula's cousins Janet (left), Monty (center), and Mike Shaw pose in front of a pickup truck, enjoying their visit. Their father, Allen, and Bill's uncle Pete Shaw owned the large turkey farm on the Heights. Note the cardboard on the front of the pickup, used to keep the radiator from freezing. The Clarkston Heights, with its wide-open spaces, was a fun place to visit. The Finnish people owned many orchard tracts in the Heights. Through the years, the Finns got tired of working 14 hours a day in the orchards. Soon, they and other farmers would be lured away by the eight-hour workdays offered by Potlatch Forest, Inc., a white pine mill in Lewiston, Idaho. Their children grew up, and most of them married and moved away. The orchard tracts were sold off to land developers. Today, it would be difficult to find a fruit orchard in the Clarkston Heights. (Courtesy of Bill Lintula.)

Four

SCHOOL RULES

Here is a historic photograph of little girls in costume playing at the Highland School. Before Highland, the very first school opened in Clarkston, Washington, in 1891. The 14-foot-by-20-foot building had 22 students. At last, formal education had come to Clarkston, Washington. (Courtesy of Asotin County Museum.)

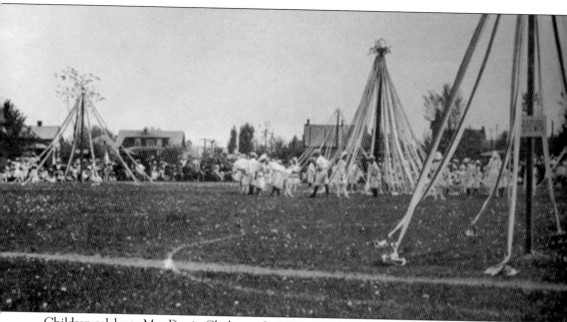

Children celebrate May Day in Clarkston. In 1906, the school became the Longfellow Building, which burned in 1921. A new high school was completed in 1923 and named in honor of Charles Francis Adams (1835–1915), the Boston financier whose efforts led to the early development of the community. (Courtesy of Asotin County Museum.)

This is the commencement announcement for the class of 1919 at Clarkston School. The class consisted of 23 students. The superintendent was Paul Johnson, and the class advisor was Mrs. Clay Palmer. The class motto was "Excelsior," which means higher, loftier. (Courtesy of John Vorous, the H. Fountain Collection.)

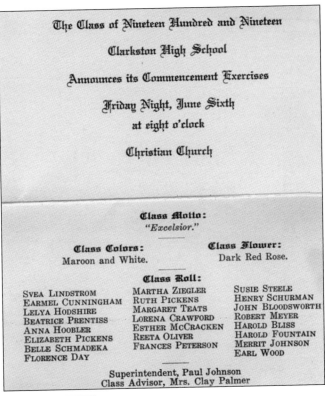

The Class of Nineteen Hundred and Nineteen

Clarkston High School

Announces its Commencement Exercises

Friday Night, June Sixth

at eight o'clock

Christian Church

Class Motto:
"Excelsior."

Class Colors:
Maroon and White.

Class Flower:
Dark Red Rose.

Class Roll:

SVEA LINDSTROM
EARMEL CUNNINGHAM
LELYA HODSHIRE
BEATRICE PRENTISS
ANNA HOOBLER
ELIZABETH PICKENS
BELLE SCHMADEKA
FLORENCE DAY

MARTHA ZIEGLER
RUTH PICKENS
MARGARET TEATS
LORENA CRAWFORD
ESTHER McCRACKEN
REETA OLIVER
FRANCES PETERSON

SUSIE STEELE
HENRY SCHURMAN
JOHN BLOODSWORTH
ROBERT MEYER
HAROLD BLISS
HAROLD FOUNTAIN
MERRIT JOHNSON
EARL WOOD

Superintendent, Paul Johnson
Class Advisor, Mrs. Clay Palmer

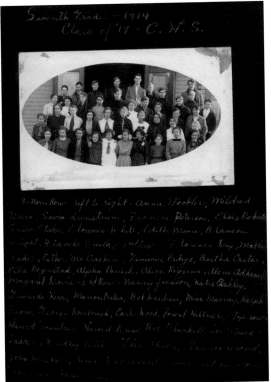

In 1901, the first schoolhouse was built at the corner of Thirteenth and Chestnut Streets. That building was destroyed by fire. Clarkston High School is named for Charles Francis Adams and is noted for the quality of its education. In 1923, the school began its reputation for having winning athletic teams. (Courtesy of John Vorous.)

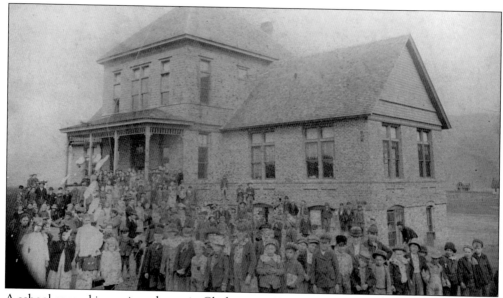

A school opened in a private home in Clarkston in 1898. In 1891, the first school was built, and it later burned down. This was Clarkston School's new Longfellow Building. It was on the corner of Thirteenth and Sycamore Streets. Built in 1906, it burned down about 1920. (Courtesy of Asotin Country Museum).

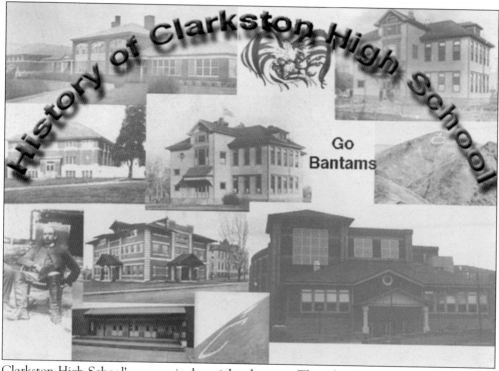

Clarkston High School's mascot is the mighty bantam. The school colors are red, black, and white. The school's rivals are the Bengals from Lewiston High School, across the Snake River in Idaho. Part of their rivalry includes the Golden Throne competition, which takes place every January. (Courtesy of Marilyn Pike Wilson.)

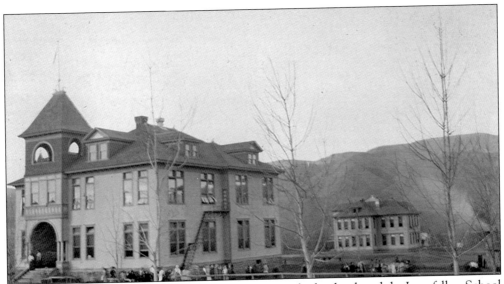

Whittier School (left), which was the original Clarkston high school, and the Longfellow School (right) were on the same block at the corner at Thirteenth and Chestnut Streets in Clarkston. This photograph was taken in 1920. A third building in the middle is not shown in this photograph. (Courtesy of Asotin County Museum.)

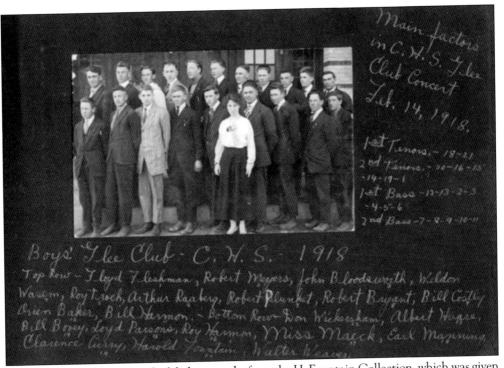

This is another of those wonderful photographs from the H. Fountain Collection, which was given to John Vorous by the Fountain family. John's grandmother went to school with these students. What is wonderful about them is they are not only interesting; the names of the students are also on them. (Courtesy of John Vorous, the H. Fountain Collection.)

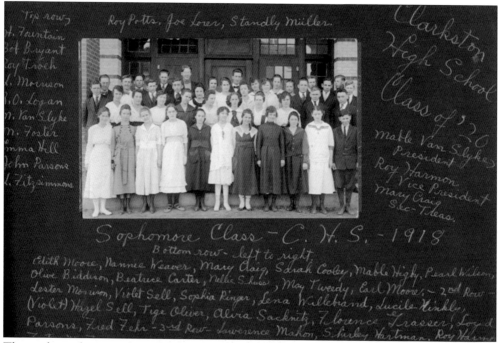

Top row→
H. Fountain
Bob Bryant
Roy Troch
L. Morrison
R. O. Logan
M. Van Slyke
M. Foster
Emma Hill
John Parsons
L. Fitzsimmons

Roy Potts, Joe Lover, Standly Miller.

Clarkston High School Class of '20

Mable Van Slyke, President
Roy Harmon, Vice President
Mary Craig, Sec-Treas.

Sophomore Class - C. H. S. - 1918

Bottom row - left to right
Edith Moore, Nannie Weaver, Mary Craig, Sarah Cooley, Mable High, Pearl Wilson, Olive Biddison, Beatrice Carter, Nellie Sluss; May Tweedy, Earl Moore; - 2nd Row - Lester Morrison, Violet Sell, Sophia Ringer, Lena Willebrand, Lucile Hinkle, (Violet) Hazel Sell, Tige Oliver, Alura Sacknitz, Florence Trasser, Loyd Parsons, Fred Fehr - 3rd Row - Lawerence Mahon, Shirley Hartman, Roy Harmon

This is the sophomore class of 1918. They would graduate in 1920. As the students wrote their names on the photograph, it is easy to identify them. Charles Francis Adams High School was a three-year school until the 1968–1969 school year. (Courtesy of John Vorous, the H. Fountain Collection.)

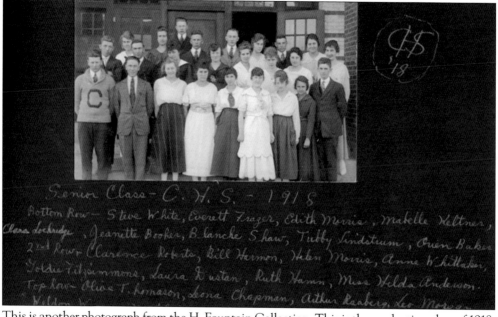

Senior Class - C. H. S. - 1918

Bottom Row - Steve White, Everett Frazer, Edith Morris, Mabelle Keltner, Clara Lockridge, Jeanette Booker, Blanche Shaw, Tubby Lindstrum, Owen Baker. 2nd Row - Clarence Roberts, Bill Harmon, Helen Morris, Anne Whittaker, Goldie Fitzsimmons, Laura Ruston, Ruth Hamm, Miss Hilda Anderson. Top Row - Olive T. Thomason, Leona Chapman, Arthur Raaberg, Leo Morse

This is another photograph from the H. Fountain Collection. This is the graduating class of 1918. The Longfellow Building served as the high school until 1923. At that time, the older students were upstairs, and the younger ones were on the lower floor. Charles Francis Adams High School was built on Sixth Street. (Courtesy of John Vorous, the H. Fountain Collection.)

This bird's-eye photograph of Clarkston High School taken in 1953 shows Smith Hall on the left and the Adams Building at center. The smaller buildings behind were are unidentified. Parking was in the location of today's main high school building. Clarkston schools continue to grow. (Courtesy of Asotin County Museum.)

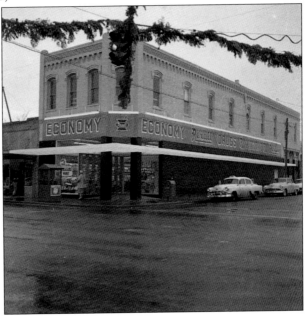

The Economy Drug in Clarkston, pictured around 1954, held a secret. Upstairs in this building, many teenage dances were held. It was called the Hut and was always filled with dancing students. The Clarkston High School students took up collections and had fundraisers to buy a juke box for their hangout. (Courtesy of Doug Renggli.)

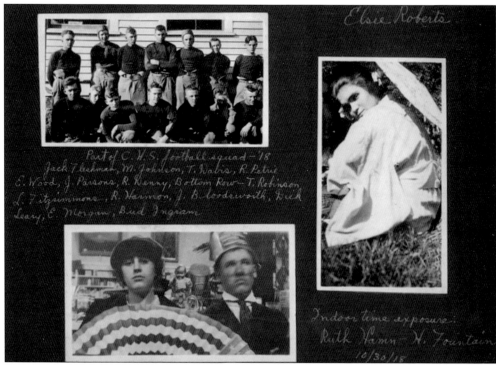

The photograph at upper left, from the historic Fountain Collection, shows football players in 1919. Clarkston always encouraged sports for its students; in time, it became the school that won the most games in its league. The school would later build a stadium. (Courtesy of John Vorous, the H. Fountain Collection.)

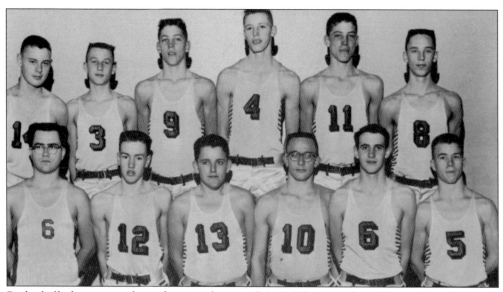

Basketball players pose for a photograph around 1960. They are, from left to right, (first row) Darrell Gomsrud, Vern Redshaw, Dick Walker, Gary Haas, Don Meyers, and Dick Bills; (second row) Daryl Estlund, Ed Fisk, David Kludt, Dick Snow, Darold Kludt, and Rich Niemi. The Bantam "B" squad turned in a fine record for the season. (Courtesy of Marilyn Pike Wilson.)

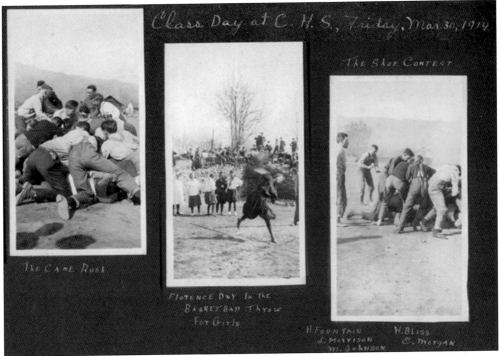

Class Day at Charles Francis Adams High School was held on March 30, 1914. Charles Francis Adams High School was a three-year school. For many years, the school has been referred to as CHS, or Clarkston High School. (Courtesy of John Vorous, the H. Fountain Collection.)

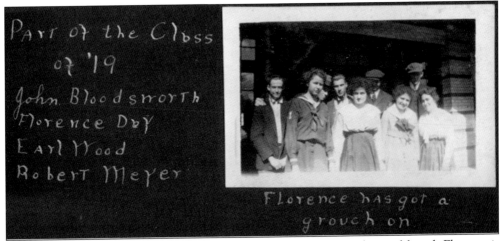

The writing on this photograph mentions that Florence has a grouch on, although Florence is not identified. These students were part of the class of 1919. (Courtesy of John Vorous, the H. Fountain Collection.)

This photograph is of Marilyn Pike Wilson, 1960 graduate, on graduation Day. Marilyn is married to Rich Wilson, class of 1958. They had three wonderful children. They formed a very successful real estate company and built residential and commercial properties for over 45 years. They love to travel the world. (Courtesy of Marilyn Pike Wilson.)

This is Karen Layton, a 1960 graduate, as a young lady, all dressed up in her beautiful gown. Karen worked at the Space Needle at the Seattle World's Fair, was a flight attendant, and was an interior designer for 40-plus years. She has two daughters and three granddaughters. (Courtesy of Karen Layton McGuire.)

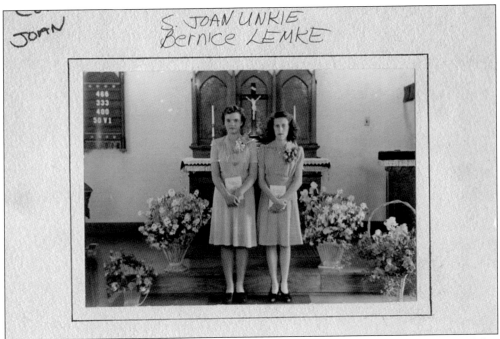

This was Confirmation day at Holy Family Church on May 21, 1944. Shown are S. Joan Unkie (left) and Bernice Lemke (right). With all the beautiful flowers and corsages, it was obvious it was a time for celebration. This wonderful photograph is from of the H. Fountain Collection of photographs. (Courtesy of John Vorous, the H. Fountain Collection.)

This was a second-grade class held at Parkway School in Clarkston in 1948. Mrs. Van Trease was the second-grade teacher. Standing from left to right are Linda Munson, Judy Duran, and Betty Ellis Jordon; the others are unidentified. Parkway was torn down to make room for a new school in 1952. (Courtesy of Linda Munson Covey.)

Second-graders sit for a class photograph in teacher Mrs. Van Trease's room. Standing in the back at the far left is Twila Johnson. Linda Munson is forth from the left in the second row. Fifth from the left in the first row is Betty Ellis. The rest are unidentified. It is believed that this took place in Smith Hall. (Courtesy of Linda Munson Covey.)

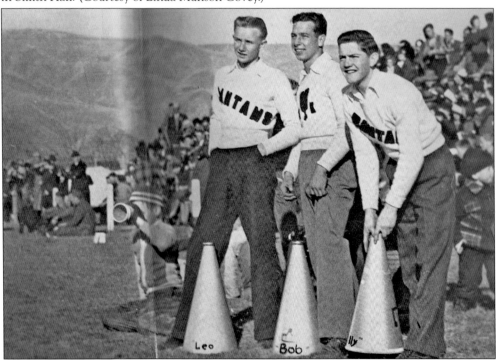

Doug Morris sent in this photograph. It is from the 1939 Bantam yearbook that his mother, Norma Way, passed on to him. In the photograph is the male cheer squad with Leo Hayworth on the left. Doug graduated from Clarkston High School with Leo's son Greg in 1967. (Courtesy of Doug Morris.)

At the annual music festival in 1961, Judy Ward Karlberg sang "The Green Leaves of Summer" and was crowned queen. She presided over her court on the first night. Later, in the Spokane Lilac Parade, Karlberg rode on a special float, accompanied by the Clarkston High School marching band. (Courtesy of Judy and Ron Karlberg.)

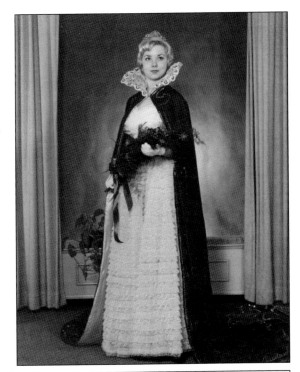

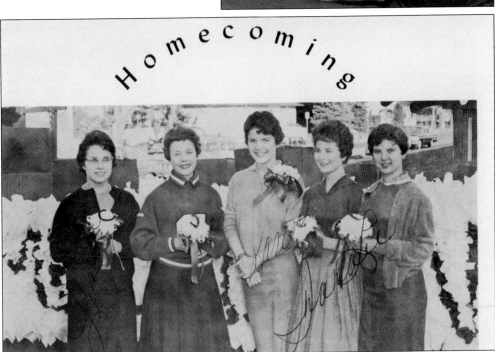

These beautiful ladies were the CHS homecoming royalty in 1960–1961. From left to right are queen Linda Kinnick, senior princess Glenna Roberts, senior princess Karen Layton, junior princess Shara Lee Grow, and sophomore princess Fredia Davidson. The homecoming game was always the rival game between Lewiston and Clarkston High Schools. (Courtesy of Marilyn Pike Wilson.)

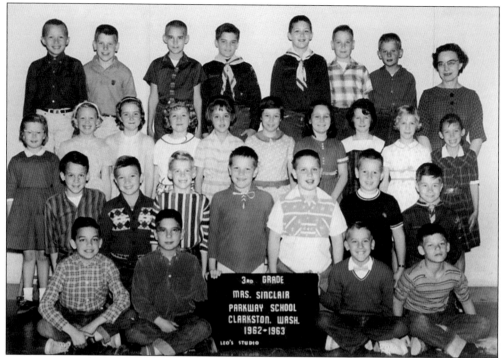

This is a 1962–1963 photograph of Parkway School's third-grade class in Clarkston. Mrs. Sinclair was the teacher. John Vorous was one of the two Cub Scouts. Although they are not identified, Jamie Latta, Nita Butler Jacura, and Sherri Smolinski Meacham are some of the children in the picture. (Courtesy of John Vorous.)

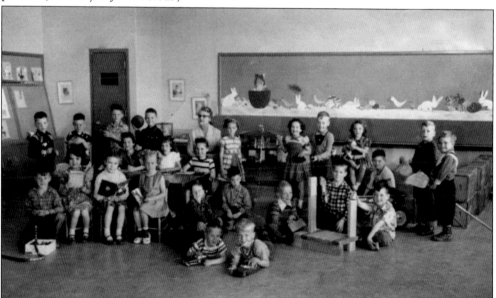

This is Bill Lintula's kindergarten picture. Mrs. Frost was the teacher. Although the children are not identified, some of those in the class were Ron Thompson, Doug Schurman, Rusty Smolinski, Steve Hopkins, Carol Ann Knox, Linda Thill, Ron Domaskin, Mike Whitman, Paul Grasser, Arnie Strang, Doug Bradly, Mike Rinard, Steve Clovis, and Lucy Clark. (Courtesy of Bill Lintula.)

The student body officers for the class of 1960 pose for a picture at Charles Francis Adams High School at the end of the senior year. From left to right are treasurer M.J. Batterton, secretary Carol Simon, vice president Gary Russell, and president Doug Helm. (Courtesy of Marilyn Pike Wilson.)

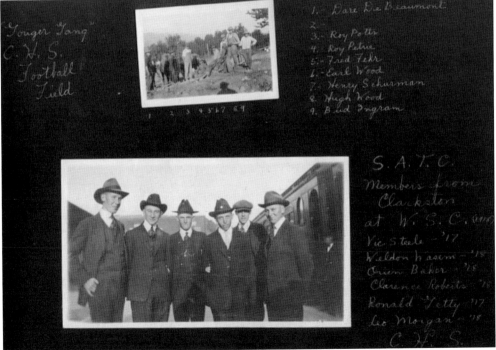

In the top photograph of this image are members of the Charles Adams High School football team. Clarkston High School has always been noted for the quality of its education, and in 1923, the school began its reputation for also having winning athletic teams. (Courtesy of John Vorous, the H. Fountain Collection.)

Marilyn Wilson, her younger sister, Darlene Pike, sitting on floor, and her older brother, Lloyd Pike, right, are seen here enjoying Christmas at their family home. Although it was 60 years ago, Marilyn and her sister remember they all received new bathrobes for Christmas. (Courtesy of Marilyn Pike Wilson.)

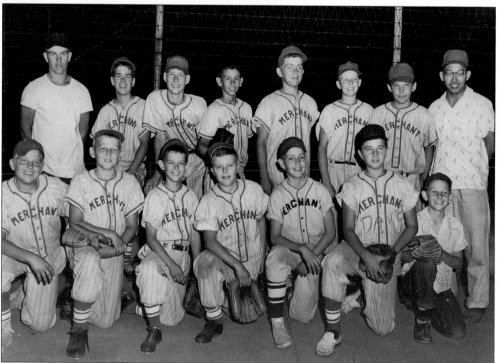

Around 1955, the Merchant Funeral Home sponsored this baseball team. Members were, from left to right, the following: (first row) unidentified, ? Skelton, Fritz Hughes, two unidentified, David Bishop, and unidentified; (second row) an unidentified coach, Kurt Shoemaker, unidentified, Lane Phillips, John Eggerling, Greg Robinson, Tom ?, and an unidentified coach. (Courtesy of Vicky and Dave Bishop.)

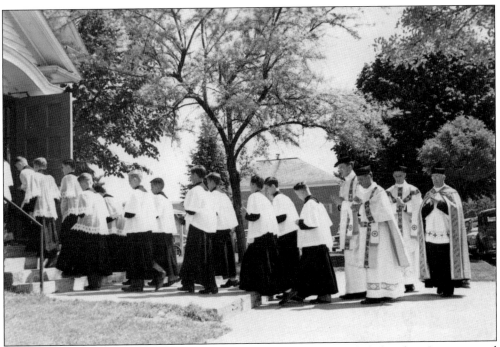

Catholics were among the early settlers in this territory. They attended church in Lewiston and were served by the Jesuit fathers of that city. Between 1900 and 1903, Sunday Mass was offered in one of the homes in Clarkston and Asotin. Later, further growth necessitated the building of the present church. (Courtesy of Asotin County Museum.)

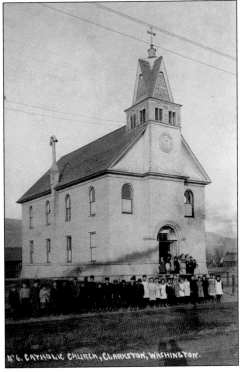

Holy Family Catholic School was started on September 6, 1921, with the building of Holy Family Church. The first five students graduated from the new Catholic school in May 1922. Prior to that, students from Clarkston were sent to Lewiston's Catholic school. The new situation was much more convenient. (Courtesy of Asotin County Museum.)

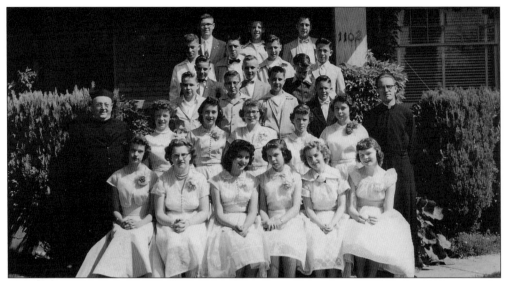

Seen here is the Holy Family School's eight-grade graduation in 1952. Father Joda is on the left. The priest on the right is unidentified. Dave Bishop is in the fourth row from the front, second from the right. Other students attending were John LeMire, Ray Duclas, Joe Feider, John Eggerling, Mark Hanna, Dick Duclas, John Kramer, Lonnie Gau, Vern Moser, Mike Wilhelm, Pat Jenkins, Dave Scully, Joan Lemm, Pat Nowoj, Jeanne Polumsky, Peggy Hoffschmilt, Leslie Schultz, Mary Bentley, Vicki Woodruff, and Patricia Fuchs of Clarkston High School. (Courtesy of Vicky Bishop.)

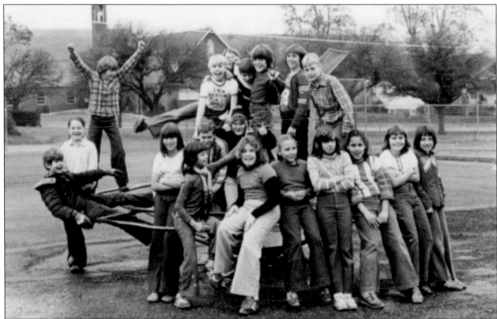

These children are in their 40s now. Bill Lintula said that these children surrounding the playground equipment were some of his students at Holy Family School. After all these years, a few are still his friends. In the 1970s, Catholic schools lost popularity and enrollment began to decline nationwide. By 1984, there were only 69 students enrolled at Holy Family Catholic School. (Courtesy of Bill Lintula.)

Here are some of the members of the Holy Family Parish in 1952. The parish consisted of members from Clarkston, Lewiston, Colton, Uniontown, and Pomeroy. A new church was planned for the Clarkston Parish and would be located diagonally across from the present structure at Chestnut and 11th Streets. (Courtesy of Asotin Country Museum.)

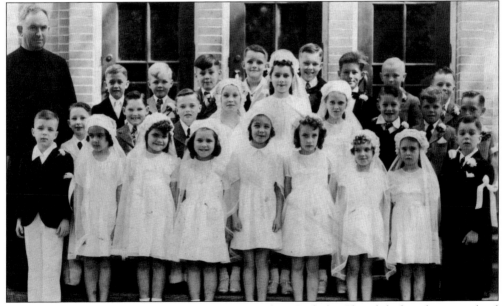

Holy Family students went to Lewiston's St. Stanislaus Catholic Church before the new school was built and received their first Holy Communion there. By the time the brick building was erected in 1937, the school population had more than doubled. The people in the photograph are unidentified. (Courtesy of Asotin County Museum.)

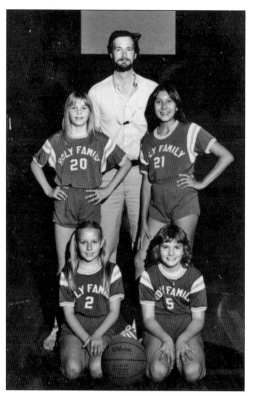

Bill Lintula said that these children were once his students at Holy Family School. The Catholic school has had a long history. The first registration for Holy Family was taken on September 6, 1921, and included 44 students. By 1937, the school population had more than doubled. (Courtesy of Bill Lintula.)

Bill Lintula taught these students at Holy Family School in the 1970s. Today, they are in their 40s, and a few are his friends on Facebook. In the past, Holy Family School sent its schoolchildren to Lewiston until it finally got its own church building. (Courtesy of Bill Lintula.)

This photograph of Patty Luther (left) and her little sister, Tammy Luther Johnston, says it all where it is written: 'You're one of my favorite people'. There is no love like sister love. They look like they are all dressed up in cute little band uniforms, ready to perform. (Courtesy of Patty Luther.)

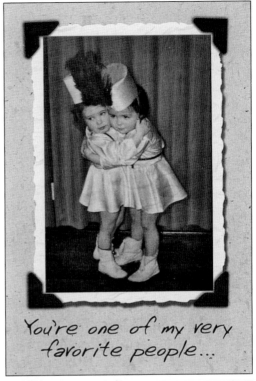

You're one of my very favorite people...

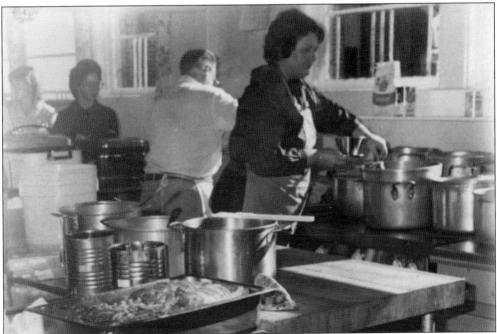

Here, Teresa Hoffman (second from left), Bob Cummings (center), and Paula Hoene (right) cook for the Holy Family School bazaar, an annual fundraising event for the Catholic school, in 1982. The school is located at 1002 Chestnut Street in Clarkston. The woman on the far left is unidentified. (Courtesy of Doug Renggli.)

Charles Francis Adams High School added a new building on Chestnut Street in 1957. This 1960 photograph shows the new entrance, east wing (classrooms), and gymnasium. The gymnasium was named after William Kramer, principal in the 1960s and football coach. (Courtesy of Bill Lintula.)

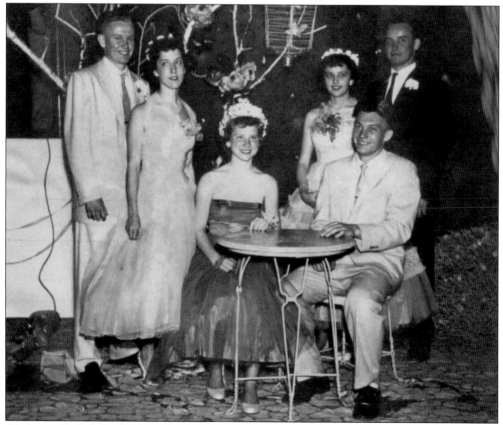

Clarkston High School's class of 1958 is probably enjoying a prom. Look at the beautiful corsages the ladies are wearing. The names of these people are not known. In the 1950s, couples always dressed up to go out. The woman always wore a beautiful dress, and the man wore a suit. (Courtesy of Rich Wilson.)

"Yea team! Fight!" was often heard from these five girls. They were the Clarkston High School "A" squad cheerleaders in 1960. Shown here are, from left to right, (first row) Donna Kludt, Glenna Roberts, and Phyllis Schwoob; (second row) Mary Jane Batterton and Judy Haney. In many cases, the school's various sports teams were victorious. (Courtesy of Marilyn Pike Wilson.)

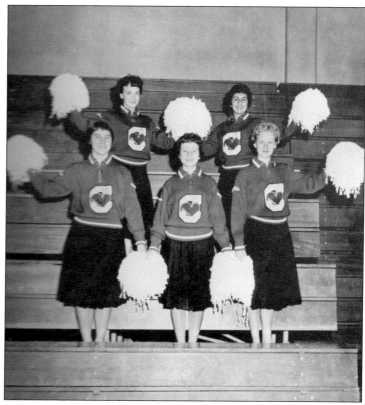

Standing in front of Charles Francis Adams High School are Judy Haney (left) and Joanne Smith. They received the high honors of valedictorian and salutatorian, respectively, of Clarkston High School in 1960. Other honorees were Mary Jane Batterton, Doug Helm, Donna Kludt, and Judy Pea. (Courtesy of Marilyn Pike Wilson.)

73

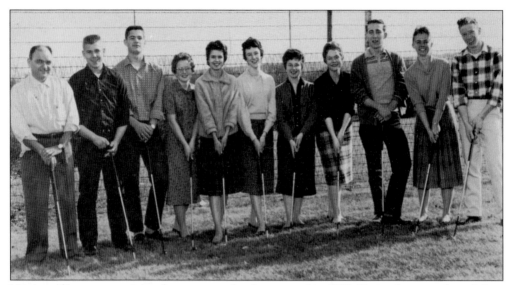

Varsity golf was one activity that many took advantage of in 1950. Posing here are, from left to right, Mr. Miltenberger (advisor), T. Ritzeimer, S. Burator, S. Johnson, P. Rogers, V. Folwer, Gayle Bishop, J. Jensen, V. Thomas, S. Arnold, and G. Mickleson. (Courtesy of Marilyn Pike Wilson.)

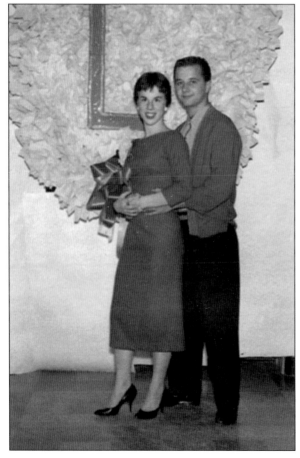

Dave Bishop, from Clarkston High School, and Karron Griffin, a Lewiston High School student, pose at Lewiston High School's 1959 homecoming dance. It was also the occasion for the big rivalry game. As these two students attended the rival schools, one wonders how the score worked out for them. (Courtesy of Dave and Vicky Bishop.)

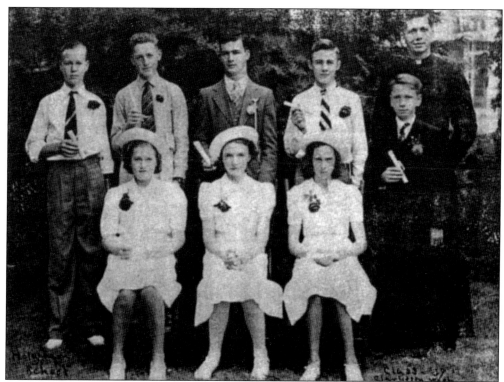

This is the 1939 graduating class of Holy Family Catholic School. From left to right are (first row) Felista Flerchinger (O'Connor), Ilene Surrey (Scharuborst) and Dorothy Galles (Matoor); (second row) Joe Behler, Chet Reidinger, Jarvis Stanfill, Patrick Doyle, and Frank Boehin. (Courtesy of Asotin County Museum.)

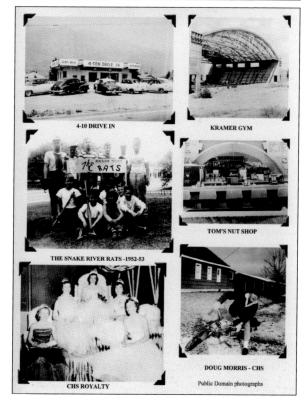

4-10 DRIVE IN

KRAMER GYM

THE SNAKE RIVER RATS -1952-53

TOM'S NUT SHOP

CHS ROYALTY

DOUG MORRIS - CHS

Public Domain photographs

This picture is made up of a series of smaller photographs that the author compiled. (Clockwise from top left, courtesy of Dennis W. Johnson, Bill Lintula, Billie Blair, Doug Morris, Marilyn Pike Wilson, and Gary Beck.)

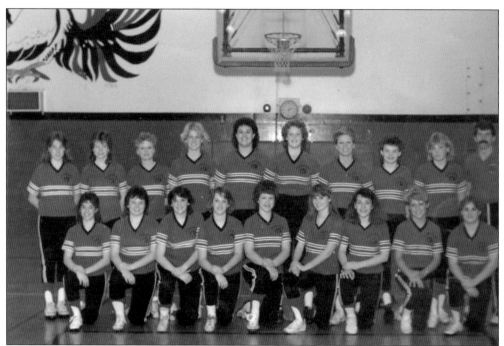

The Clarkston girls' basketball team poses for a photograph. The Clarkston Education Foundation awards a scholarship to a graduating senior who demonstrates academic promise and financial need. This award was created by community members who wanted to broaden the horizons and prepare students to experience life in and beyond the valley. (Courtesy of Marilyn Pike Wilson.)

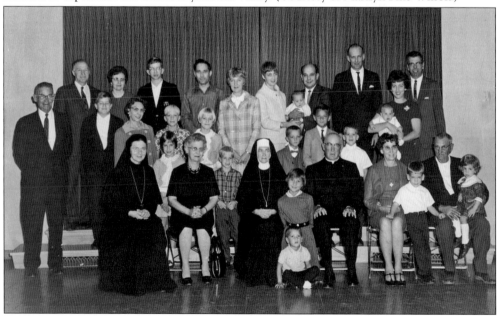

This undated photograph shows people associated with the Holy Family Catholic School. Holy Family School has been educating the whole child since 1921. A modern brick building was erected in 1921, but with more enrollment, building began again on May 9, 1950, to add on to the existing school. (Courtesy of Asotin County Library.)

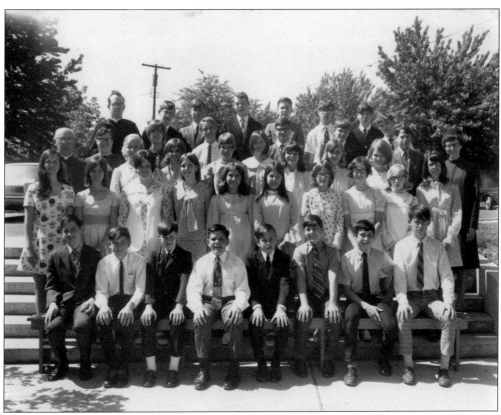

This photograph of an unidentified class of Holy Family School was from the school year of 1969–1970. The ground-breaking of the new church was on July 1, 1962. The 25th anniversary mass of the dedication of the Holy Family Catholic Church was celebrated on October 16, 1988. (Courtesy of Asotin County Museum.)

This is a photograph of, from left to right, Ron Gager, Leta Rogers, and Lee Luther enjoying time together in front of their cool car around 1955. Teenagers who had their own cars would pick up friends and cruise Bridge Street and head for the 410 Drive-In. (Courtesy of Patty Luther.)

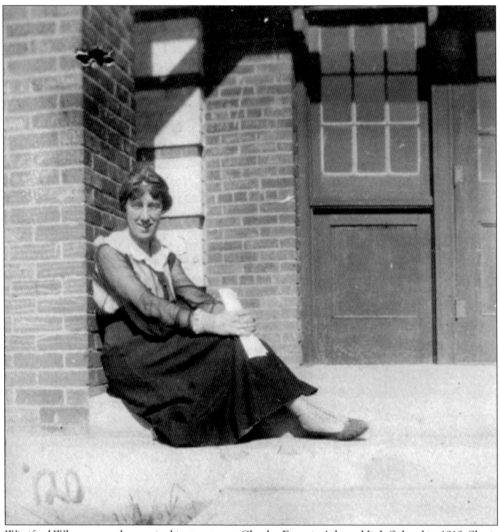

Winifred Wherry was the musical instructor at Charles Francis Adams High School in 1919. She is sitting on the steps of the school. In those days, only a few professions were available to women, usually either being a teacher or a nurse. (Courtesy of John Vorous, the H. Fountain Collection.)

Five

WHERE DID THE BEACH GO?

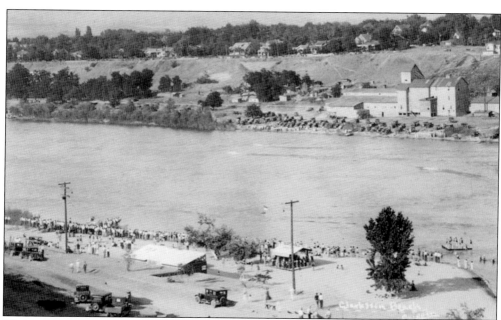

The river provided a major recreation site for Clarkston residents. The *Pullman Herald* of July 15, 1921, described the beginning of the Clarkston Beach this way: "The Clarkston beach was favored with a natural jetty of rock extending into the river just east of town." (Courtesy of Dennis W. Johnson.)

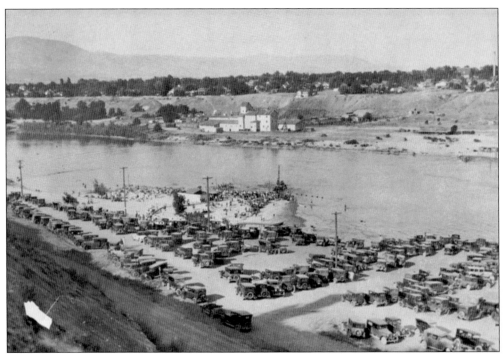

The new Clarkston Beach is in the foreground of this photograph. It was an extremely popular place, judging from all the automobiles parked there. Lewiston, Idaho, is visible across the Snake River, and the Nez Perce Roller Mills are in the background. (Courtesy of Nez Perce County Historical Society.)

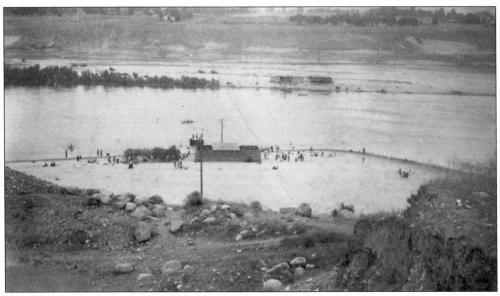

This jetty has deflected the current to the Lewiston side, allowing a fine beach of clean sand to be deposited on the Clarkston side of the river, while a large pool of comparatively still water makes bathing facilities the best in this beautiful area. (Courtesy of Asotin County Museum.)

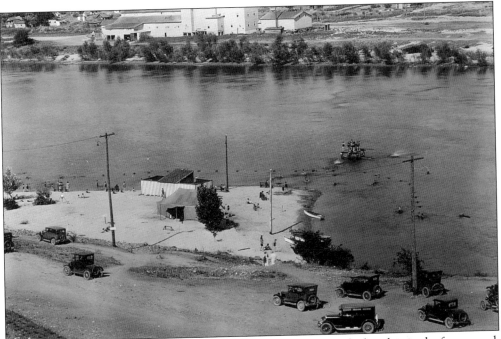

This Clarkston Beach photograph was taken about 1929 or 1930. The beach is in the foreground. Just beyond are the diving board and the tower in the river. Lewiston Beach can be seen across the river. This photograph was taken before the permanent beach houses were built in the early 1930s. (Courtesy of Nez Perce County Historical Society.)

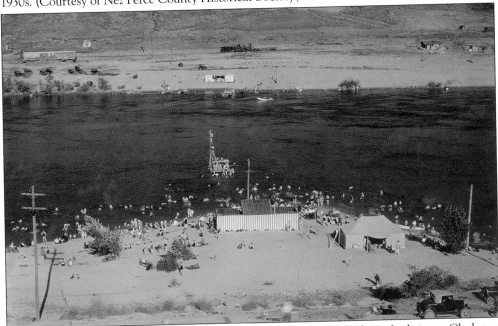

Residents of other communities took advantage of the splendid bathing facilities at Clarkston Beach, or Chestnut Beach, as it was originally called. The beach, just east of town, had a natural jetty of rock extending into the river, making it one of the most enjoyable beaches in the area. (Courtesy of Asotin County Museum.)

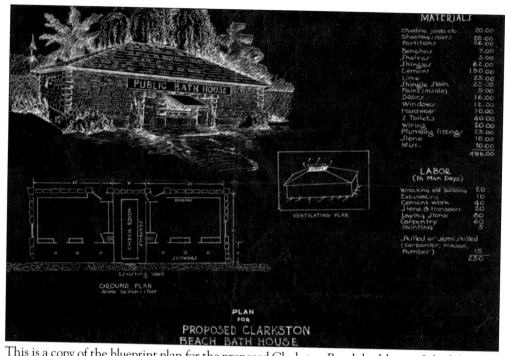

MATERIALS

Studding, joists etc	20.00
Sheeting (roof)	26.00
Partitions	26.00
Benches	7.00
Shelves	5.00
Shingles	62.00
Cement	150.00
Lime	25.00
Shingle Stain	25.00
Paint (inside)	5.00
Doors	16.00
Windows	12.00
Hardware	10.00
2 Toilets	40.00
Wiring	20.00
Plumbing fittings	25.00
Stone	10.00
Misc.	10.00
	496.00

LABOR
(In Man Days)

Wrecking old building	20
Excavating	10
Cement work	40
Stone & transport	20
Laying Stone	80
Carpentry	60
Painting	5
Skilled or semi-skilled (carpenter, mason, Plumber)	15
	250

VENTILATING PLAN

GROUND PLAN
Scale ⅛ inch = 1 foot

PUBLIC BATH HOUSE

CHECK ROOM
SHELVES
BENCHES
SHOWERS
Existing Wall

PLAN
FOR
PROPOSED CLARKSTON
BEACH BATH HOUSE

This is a copy of the blueprint plan for the proposed Clarkston Beach bathhouse. It had showers, electricity, and a storefront. It is interesting to look at the prices listed and to compare them to what things would cost now. (Courtesy of Asotin County Museum.)

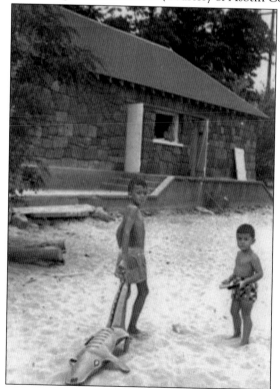

These two boys, Kenneth Heintz (left) and Larry Heintz (right), enjoy playing at the Clarkston Beach. The beach house was very popular with the children, as there were showers and an outside water faucet to wash the sand off their feet. The best part was the candy sold inside! (Courtesy of Dennis W. Johnson.)

These two bathing beauties enjoy the pleasures of the river and the sand at the new Chestnut Beach in Clarkston. It would later be called Clarkston Beach. The lady seated and playing the ukulele is Ava Lou Lewis, John Vorous's grandmother. The other lady is unidentified. (Courtesy of John Vorous.)

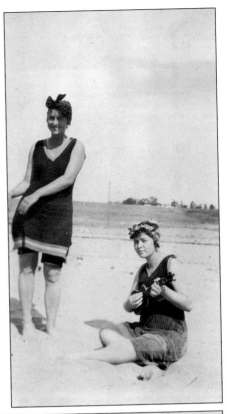

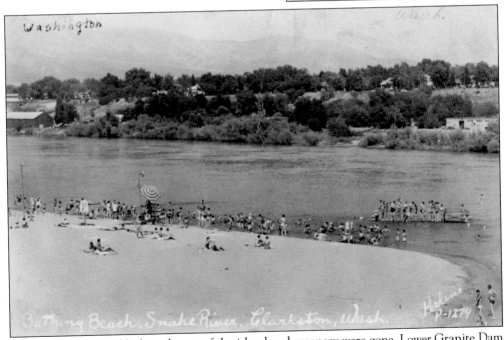

In 1972, the highland hole and most of the island and greenery were gone. Lower Granite Dam was under construction for 10 years. Clarkston Beach, located below Beachview Park, borders the free-flowing Snake River. The Clarkston Beach was lost forever. (Courtesy of Bill Lintula.)

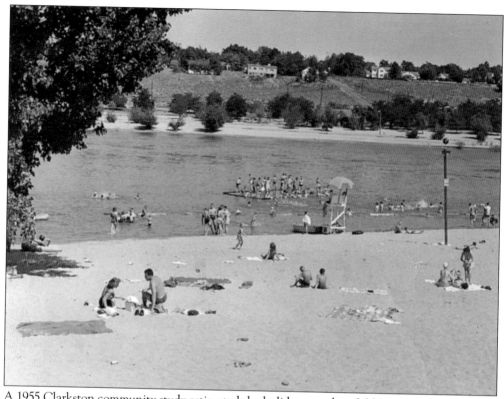

A 1955 Clarkston community study estimated the holiday crowds at 3,000 people that year. The beach was open in July and August. The lifeguard, assistant lifeguard, and "extra beach help" accounted for $2,000 of the city's $3,600 parks and recreation budget in those years. (Courtesy of Asotin County Museum.)

Judith Geidl (right) and an unidentified friend have their photograph taken at Clarkston Beach on a sunny afternoon around 1957. Judith was from Lewiston, Idaho. Everyone knew where the best beach was and where they could find their friends in the summer. (Courtesy of Judith Geidl.)

This is what is left of the old Clarkston Beach. This photograph was taken in 1983 or 1984. There was an island toward the Idaho side, underneath the interstate bridge. There were swamp areas near Red Wolf Crossing. At certain times of the year, it was possible to walk halfway to the other side. The beach was covered by slack water in 1975, and everything is gone. (Courtesy of Bill Lintula.)

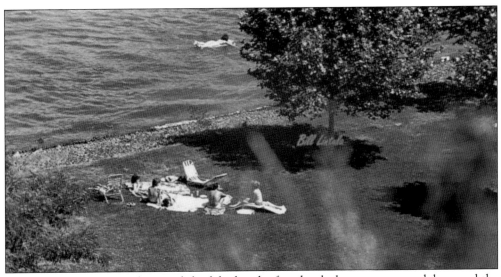

This photograph shows what was left of the beach after the slack water came and destroyed the old beach. This was taken at the same time and same place, but from a different angle, as the photograph before. There is only some grass and trees left, with large river rocks and no sand. (Courtesy of Bill Lintula.)

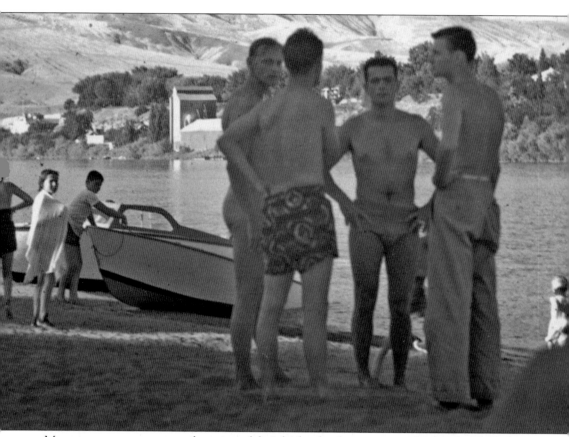

Many a teenager spent a good portion of their high school summers on the wonderful Clarkston Beach. Besides swimming and sunbathing, some went boating or waterskiing right from the beach. (Courtesy of the Paul Philemon Kries Photographs 1950–1970 [PC 28], Manuscripts, Archives, and Special Collections [MASC], Washington State University Libraries.)

This wonderful photograph shows how large Beachview Park was, and it also shows the road down to the beach, where there was another little park. On the far right is the beach house. This photograph offers a great view of the sandy beach. (Courtesy of Nez Perce County Historical Society.)

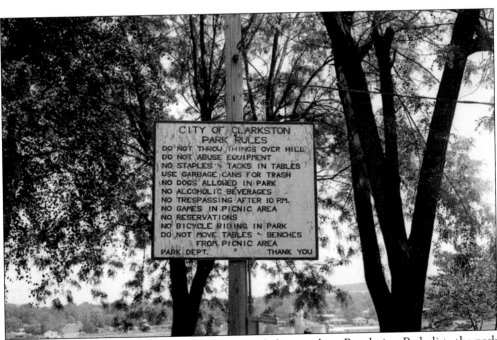

This truly was a sign of the times. The notice, nailed to a pole at Beachview Park, lists the park rules. It was so fun being at the park, the pool, and the beach that obeying the rules was little to ask. (Courtesy of Bill Lintula.)

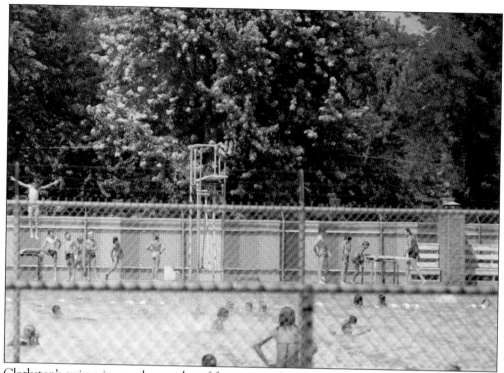

Clarkston's swimming pool was a lot of fun, in part because it had a high-diving board. Each summer day saw the pool filled with happy children. It was right next to Beachview Park and not far from Clarkston Beach. How could someone be unhappy in an environment like this? (Courtesy of Bill Lintula.)

Just above Clarkston Beach was the fantastic Beachview Park. There was lots of green grass, and the beautiful tall trees cooled everyone when the wind blew. The park had a great view of the river. Many picnics were held there. (Author's photograph).

Beachview Park was a perfect place for the CHS class of 1966 to hold a 10-year reunion. Here, they are having a picnic, with buckets of chicken from Sharps, a local fast-food restaurant. Nothing made folks feel that they had come home to friends more than being at the park. (Courtesy of Bill Lintula.)

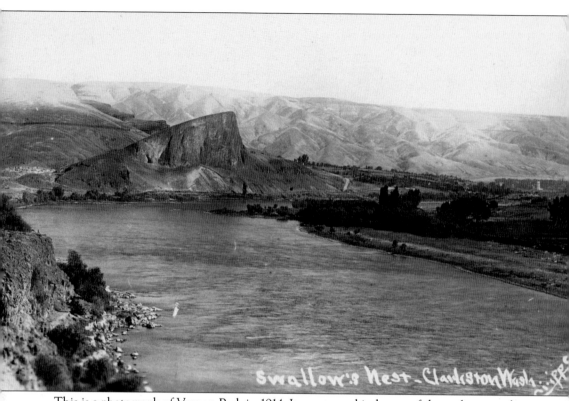

Swallow's Nest - Clarkston Wash.

This is a photograph of Vernon Park in 1914. It was named in honor of the real estate salesman "Col" E.T. Vernon. In the mid-1920s, many churches would hold Sunday evening services in Vernon Park in the summertime. Pastors would take turns preaching. (Courtesy of Asotin County Library.)

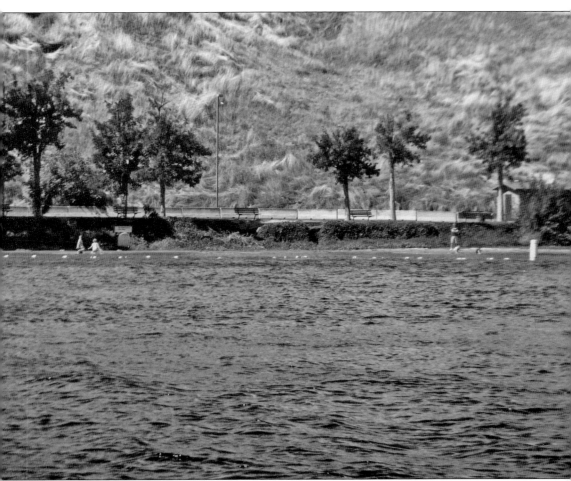

This is what the Clarkston Beach looks like in 2015 after the slack water covered it. It is mostly gone. The river was raised to the levees, and much of the beach was lost. Beachview Park is still there, as it is on the hill above where beach was. (Author's photograph.)

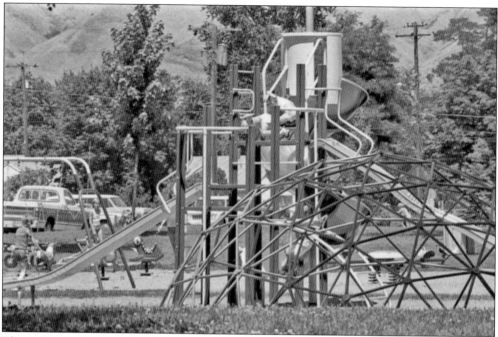

This is the jungle gym at Beachview Park. It almost looks like a piece of modern art. It has been a fun place to play for many children through the years. The park has other features for children, such as swings to play on. (Courtesy of Bill Lintula.)

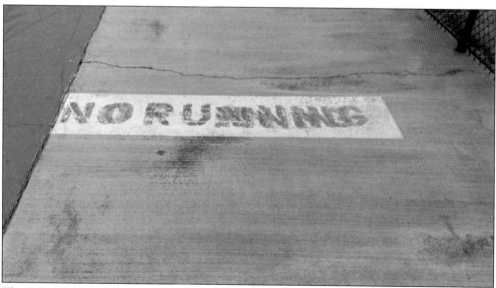

This "No Running" sign painted on the sidewalk is all that is left of the wonderful Clarkston pool. The pool was taken out; in its place, a skateboard park was installed. Although times have changed and there was a greater need for the skateboard park, many would have preferred that the pool remain. (Courtesy of Bill Lintula.)

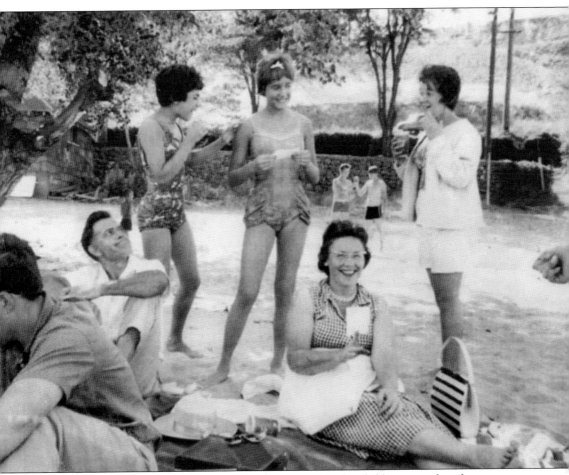

The park right above the beach was an area where not only the children came but the parents, too. The girls are, from left to right, Linda Hicks-Watson, Betsy Plunket-Paffile, and Kristy McMurray. Karen Victory's father, Marvin Victory, is seated on the left, and her mother, Edna, is on the right. (Courtesy of Karen Victory.)

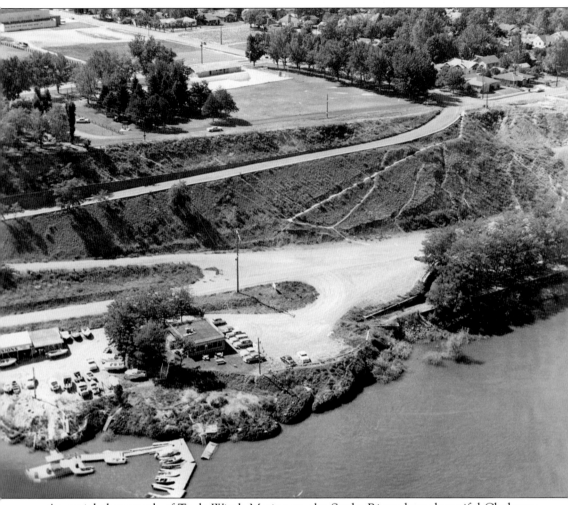

An aerial photograph of Trade Winds Marina on the Snake River shows beautiful Clarkston, Washington. The marina, a very popular place in the 1950s and 1960s, was covered by slack water from Lower Granite Dam in 1975. Boats have always been a tradition on the river. A brochure from the City of Clarkston expresses it very well: "The river valley's warm climate is often called 'The Banana Belt'. It enables residents and visitors to enjoy year-round outdoor activities such as golf, fishing and walking the trails along the beautiful Snake River. Sparkling area rivers and creeks beckon you outside where cruise ships, jet boat rides and races, boating, water skiing, rafting and world famous steelhead, chinook and trout fishing await. Nearby forest lands provide hunters with deer, elk and game birds." (Courtesy of Asotin County Museum.)

Six

FACES AND PLACES

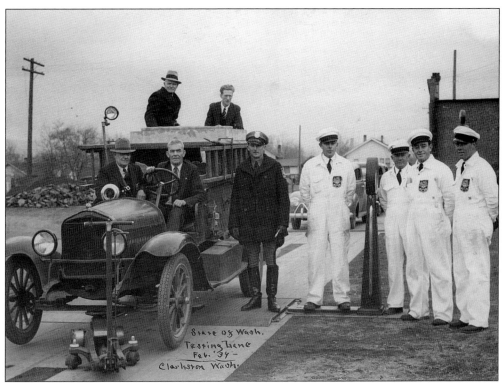

This is a photograph of the State of Washington checking a car in the testing lane in February 1939. It was important to test cars for safety. People in the photograph include Joe Mackey (top) and Ike Burnell (in the seat). The rest are unidentified. (Courtesy of Asotin County Museum.)

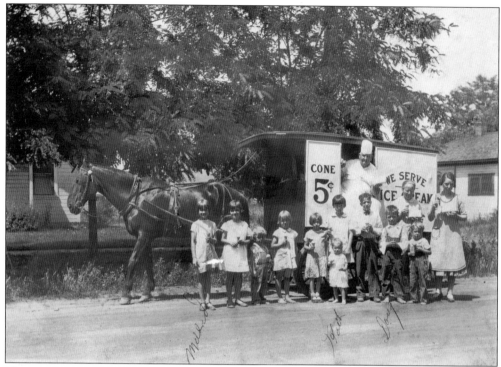

The ice cream man was a popular person during hot days in Clarkston, as shown in 1927. Names that are labeled on the front are Mildred, Kath, and Doug. Two unidentified neighborhood women were volunteers who helped out and also lived on Fifth Street in Clarkston. (Courtesy of Asotin County Museum.)

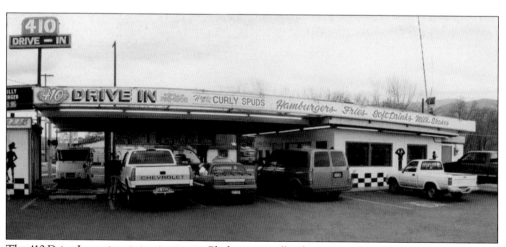

The 410 Drive-In, an iconic institution in Clarkston, is still in business today. Growing up in Clarkston was all about cruising Main Street in Lewiston and then driving back to this establishment for burgers and the famous curly fries, which the drive-in still serves. (Courtesy of Bill Lintula.)

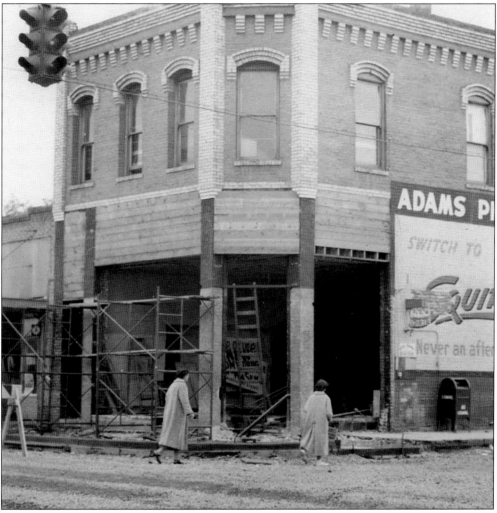

Adams Pharmacy in Clarkston, when it was located at Sixth and Sycamore Streets, was the typical 1950s soda fountain. Flavored Cokes were always a favorite. The Bantam Hut was on the second floor. The class of 1960 held its 50th reunion in the street in front of it. (Courtesy of Asotin County Museum.)

Another great gathering place in Clarkston was Tom's Nut Shop. Pictured in front of it are, from left to right, Dorothy Bashore, Tom Smith Sr., Nina Robinson, and Tom Smith Jr. Many memories were made there. In fact, the class of 1962 has enjoyed lunch there as part of its reunions. (Courtesy of Billie Waide.)

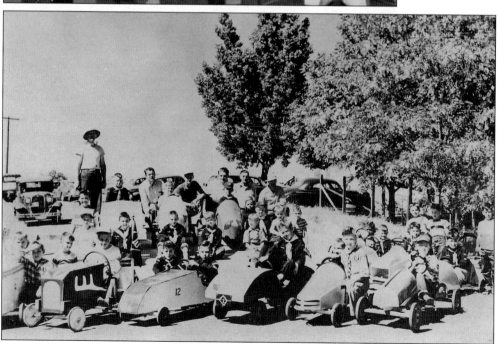

This photograph of a soapbox derby race was taken in the 1950s. Dave Bishop was in Cub Scouts and still at the Catholic school. Bishop, about nine years old at this time, is standing third from right. The others are unidentified. (Courtesy of Vicky and Dave Bishop.)

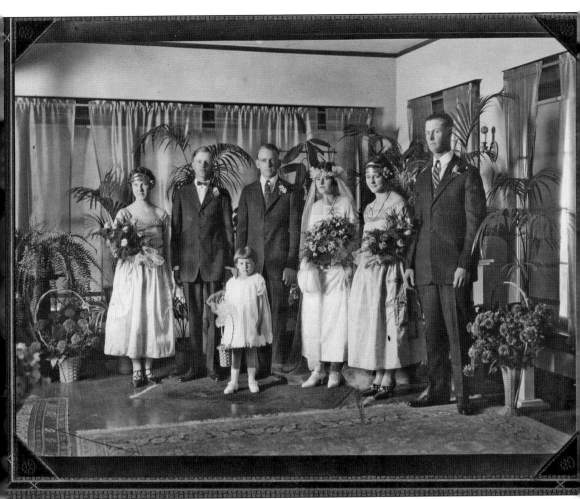

This is the wedding group picture of John Vorous's grandfather Floyd and grandmother Ava L. Lewis in 1924. Floyd and Ava are the center couple in this photograph. The Vorous family started the Vorous Company, selling Toro lawn mowers, presto-logs, and seed, and doing mower repair. (Courtesy of John Vorous.)

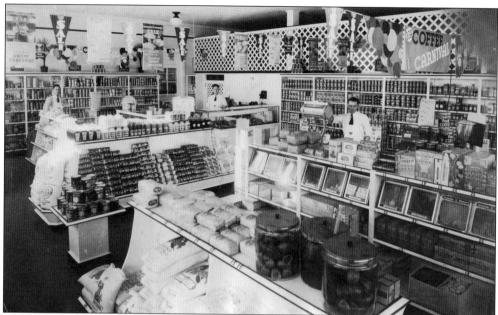

This is the interior of City Food Market, looking toward the southwest corner of the store. The market was located on the corner of Fourth Street and Main Street (now known as Diagonal Street) in Clarkston. Maurice Engle is at center behind the counter. (Courtesy of Asotin County Museum.)

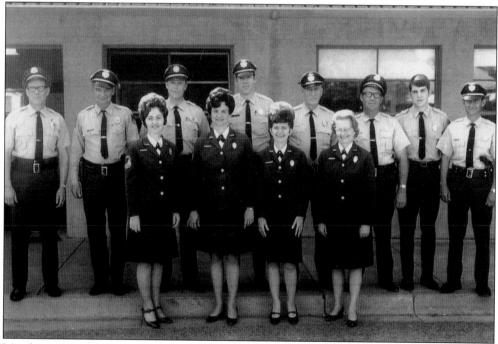

Members of the Clarkston Police around 1967–1969 are, from left to right, as follows: (first row) Maxine Clark, Arlene Moon, Donna Burke, and Nellie Green; (second row) Bo Miller, Hubert Dimke, Andy Anderson, Gordie Shoemaker, Bill Randall, Jerry Steiner, John Dimke, and Woody Barker. (Courtesy of Asotin County Museum.)

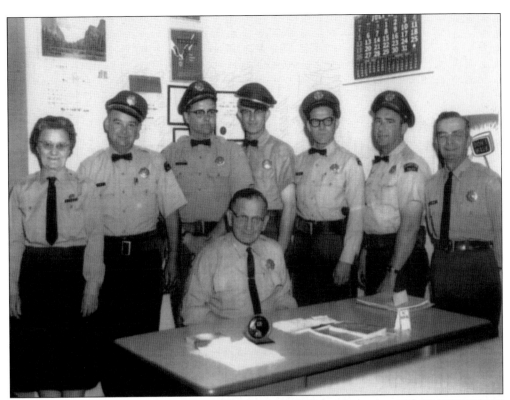

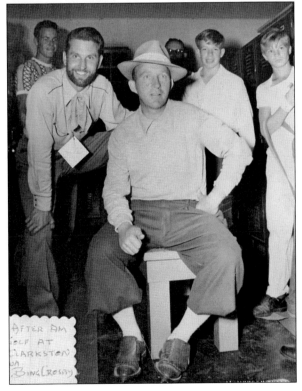

Officers of the Clarkston Police Department around 1964–1967 are pictured at the station at 828 Fifth Street. The policewoman on the left is unidentified. The other officers are, from left to right, Hubert Dimke, Herbert Reeves, Bob Kreutz, Bo Miller, Jerry Steiner, and Vern Harmon. Police chief Leo Hellings is seated in front. (Courtesy of Asotin County Museum.)

The photograph of Bing Crosby was taken at Clarkston Golf & Country Club around 1950. The event was an invitational eight-man tournament. Al Munson, who took this photograph, was a freelance photographer in Lewiston, Idaho. Crosby was born in Tacoma, Washington, and attended Gonzaga University in Spokane. (Courtesy of Linda Munson Covey.)

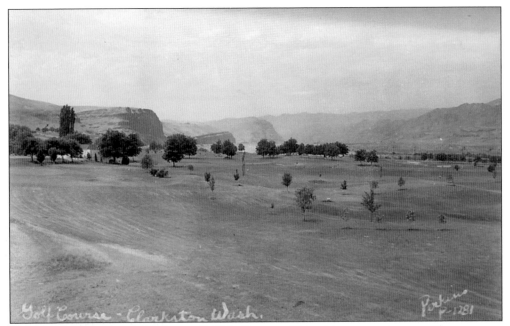

Before it was the present Clarkston Golf & Country Club, this was a cemetery. The cemetery went bankrupt, and the few bodies were moved. The area where they were buried is near the No. 3 tee and fairway, the No. 2 green, and part of the No. 2 fairway. (Courtesy of Asotin County Museum.)

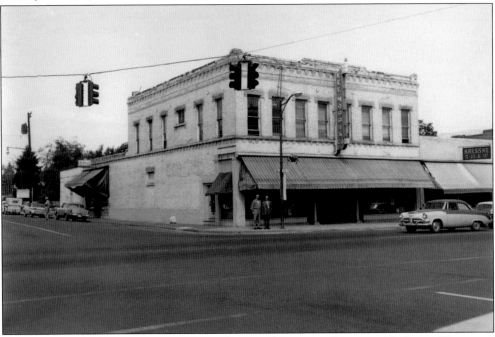

The Lee Morris Building is on the corner of Sixth and Sycamore Streets in Clarkston. The actual address is 844 Sixth Street. The building, completed in 1902 or 1903, housed the Lee Morris Company clothing store from 1916 to 2009. It was famous for having an elegant old cash register. (Courtesy of Asotin County Museum.)

Downtown Clarkston, Washington, is seen here in 1937. The location is near the corner of Sixth and Sycamore Streets. The photograph was taken facing north. The Lee Morris Building is on the left in the foreground. Lee Morris, a Minnesota native, started the mercantile store in 1916. (Courtesy of Asotin County Museum.)

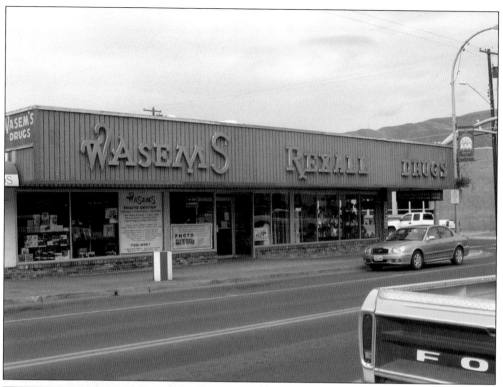

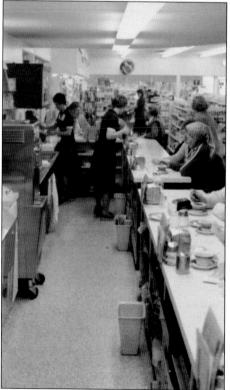

Weldon B. Wasem, a Clarkston High School graduate who earned his degree in pharmacology from Washington State College, brought the Clarkston Drug Store in 1925. It burned down in the late 1920s. He rebuilt and reopened it in his own name, operating it until 1936. (Courtesy of Asotin County Museum.)

The Wasem's lunch counter has been a longtime staple. It has had to give a higher level of service than chain stores. It served great homemade food at the coffee shop. The establishment had some great cooks back then. (Courtesy of Asotin County Museum.)

This is Madie Childers Morris, born around 1890, preparing for Thanksgiving dinner at the family farm on Deadman's Creek near Ping. She married Delbert Harvey Morris (an itinerant preacher), and she had many children, only six of whom survived to adulthood. Madie died following World War II in Lewiston of diabetes. (Courtesy of Doug Morris.)

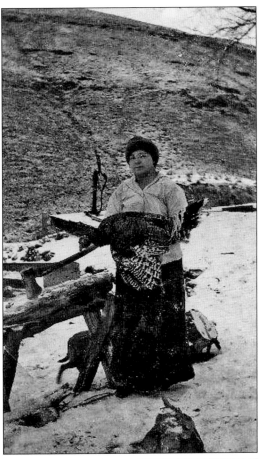

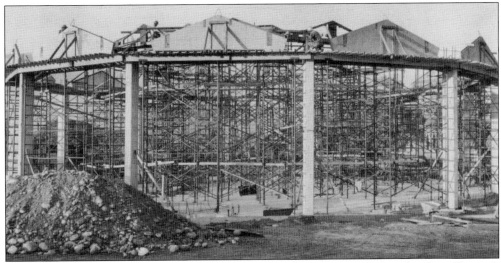

This is a photograph of the walls rising on the new Holy Family Catholic Church at Eleventh and Chestnut Streets. Prefabricated panels of concrete with a quartz aggregate exterior would be used for the upper portion of the walls. Colored chunk glass also would be used as translucent windows and for a 60-foot tower. (Courtesy of Asotin Country Museum.)

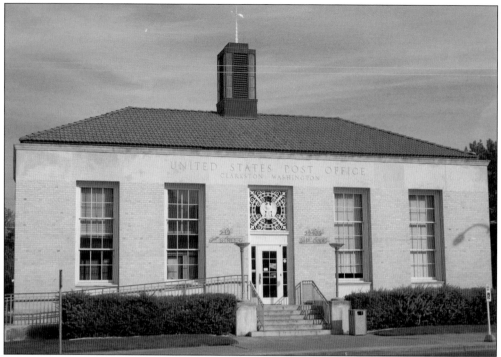

This is a photograph of the post office building at the intersection of Sixth and Chestnut Streets in Clarkston, Washington. The address was 949 Sixth Street. This view is of the west side of the building from Chestnut Street. The post office is now closed. (Courtesy of the Asotin County Museum.)

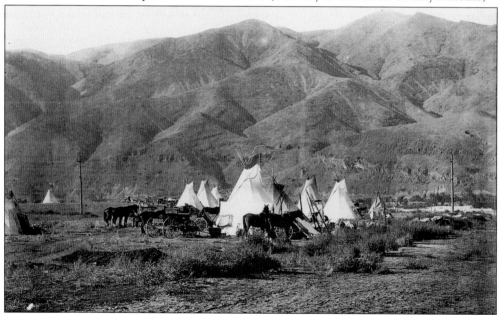

This undated historical photograph is from an old glass negative. The area where the photograph was taken is approximately the location of Sterlings Savings, 3030 Diagonal Street, in Clarkston today. The view is towards the Lewiston Hill. Jawbone Flats was hardscrabble dry sage brush and sand. (Courtesy of Asotin County Museum.)

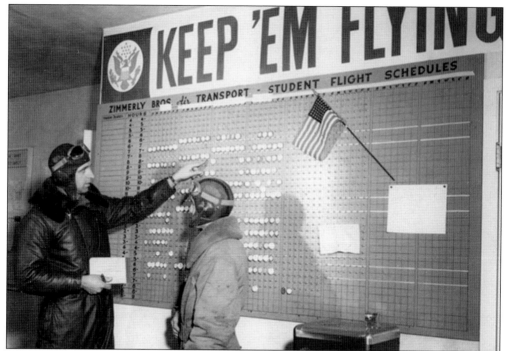

Located along the beautiful Snake River, west of its confluence with the Clearwater River, the Clarkston airport was dedicated in 1937 by Washington governor C.D. Martin. It was the pride of the city. That came seven years before the Lewiston airport was dedicated. Clarkston's airport was one of the busiest in the region. Some 35 airplanes flew 10 hours a day to train the pilots who would eventually fly over the Pacific and Europe in World War II. By the end of the war, more than 2,000 pilots had received training in Clarkston. (Courtesy of Asotin County Museum.)

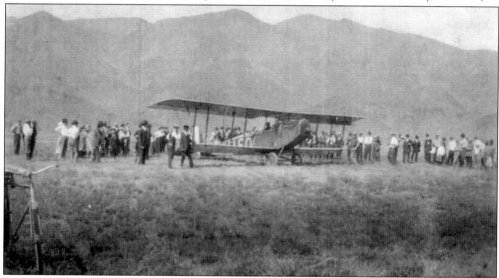

A crowd gathers around a biplane at the airport in Clarkston, Washington, around 1914. In the 1940s, the airport was more than just a training ground for military pilots. It also was the birthplace, ironically, of Idaho's first airline, Zimmerly Air Transport, which was started by Bert and Fred Zimmerly. (Courtesy of Asotin County Museum.)

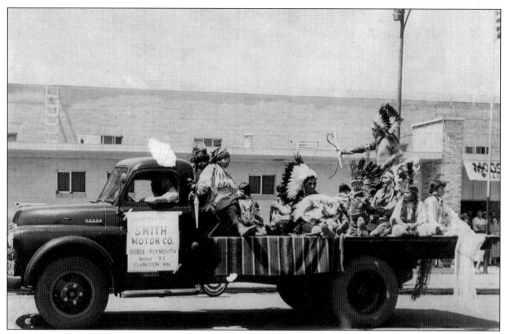

Members of the Nez Perce tribe ride on the back of a flatbed truck in a parade in Clarkston, Washington, in the 1950s. It was most likely the Rodeo Parade, as the tribe always participated in this event. The Moose Lodge at 814 Sixth Street is in the background. (Courtesy of Doug Renggli.)

When Lancer Lanes was built, lumber buggies from Potlatch Forest, Inc., were used to move the lanes from Kingpin Lanes to Sixth Street. Lancer Lanes had a popular restaurant called the Red Shield with a bar called the Armour Room. The restaurant was known for its crab melt sandwiches. (Courtesy of Doug Renggli.)

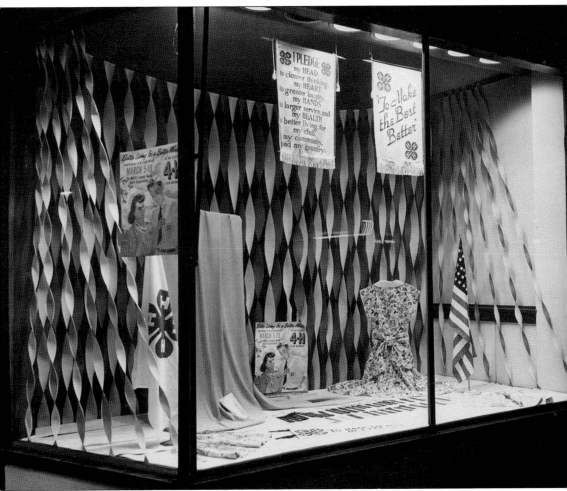

This is a great 4-H window display in celebration of National 4-H Club Week, March 5–13, 1949. The display was set up by the Cloverette 4-H Club in the window of the Washington Water Power Co. in Clarkston. Mrs. William Mundt was the leader of the club. (Courtesy of Doug Renggli.)

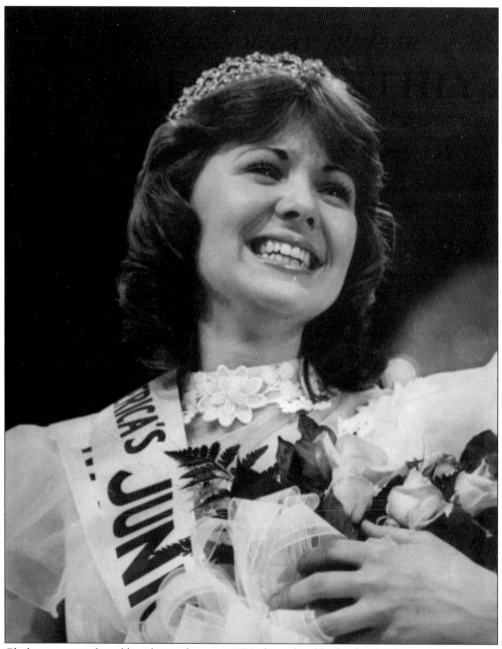

Clarkston received a public relations boost in 1976 when a local high school girl, Lenne Jo Hallgren, won the national America's Junior Miss competition. Lenne's win gave Clarkston a shot in the arm and recognition on the national stage. This was a proud moment for the valley, especially Clarkston. (Courtesy of Doug Renggli.)

This photograph shows the start of construction of Clarkston's new post office. A beautiful brick building, it was the centerpiece in the heart of the town. The post office was eventually closed due to government shutdowns. (Courtesy of Asotin County Museum.)

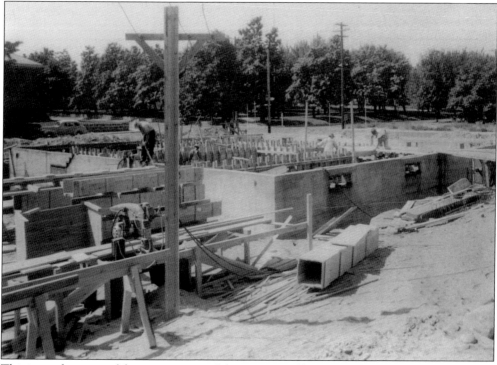

This is another view of the construction of the new post office. Post offices were important in the early days of a new town. They were one of the first buildings erected, as settlers needed to have a place to be able to get in touch with each other. (Courtesy of Asotin County Museum.)

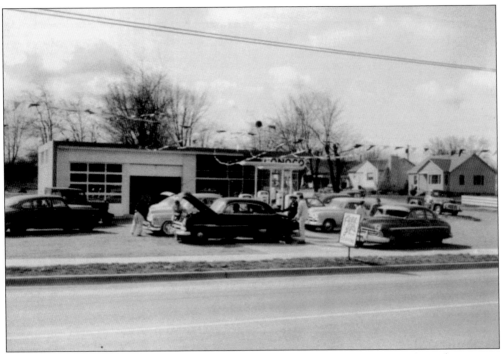

The service station on Bridge Street in this photograph was a popular one. In those days, it was easy for young men to get a job pumping gasoline, washing windows, and checking oil for patrons. Gasoline was only 24¢ a gallon. (Courtesy of Nez Perce County Historical Society.)

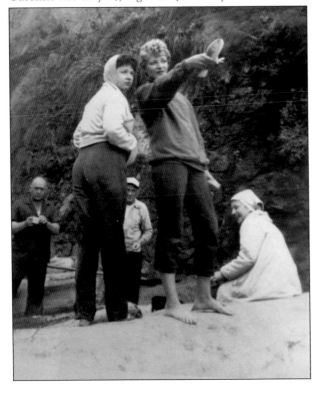

Judy Ward Karlberg (left) and friends are seen near the river. There were a lot of beaches up and down the Snake River, especially on the Clarkston side. Driving around and exploring along the river were popular activities for teenagers. Being young meant looking for adventure. (Courtesy of Judy and Ron Karlberg.)

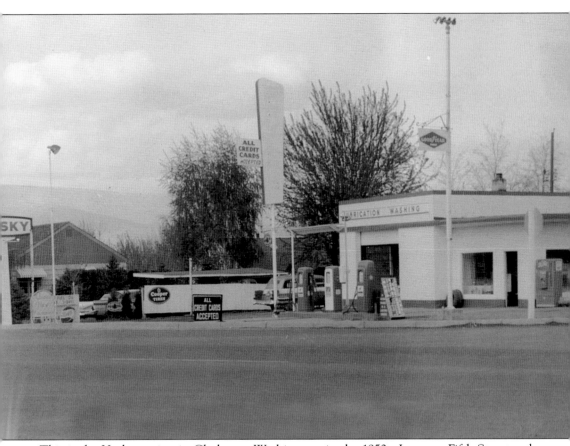

This is the Husky station in Clarkston, Washington, in the 1950s. It was at Fifth Street and Highland Avenue and was operated by Rex Madsen, who had 30 years of experience. Gas prices at the time would probably have been around 20¢ a gallon, and the price included everything from having one's windows washed to air checked, and sometimes, a free set of glasses was thrown in. (Courtesy of Asotin County Museum.)

"Go Bantams" was on this Clarkston High School tennis court's sign in red and white, which are the school colors. This sign was a symbol of Clarkston High School's student loyalty. It was done around the time that remodeling had taken place at the school and new buildings were added. (Author's collection.)

This photograph shows the beautiful yard of the Layton children's aunt Florence in Clarkston. As children, they loved to play there. Nicki (?) is at the left, Karen Layton is second from left, and her brother, Rick Layton, is center. The other family members are unidentified. Karen and Rick graduated from Clarkston High School in 1960 and 1961 respectively. (Courtesy of Karen Layton McGuire.)

This photograph shows two darling little girls sitting on a front porch in Clarkston, Washington. Nicki Buchanan Weber (left) and Karen Layton McGuire (right) are cousins. They are all dressed up and look like they are ready to possibly play or go to church. (Courtesy of Karen Layton McGuire.)

In this historic photograph, four girls play in a yard. It looks like they are performing acrobatics. It must have been wonderful for the residents of Clarkston to finally have a water supply and nice yards, as well as larger roads, after the irrigation system was installed. (Courtesy of Asotin County Museum.)

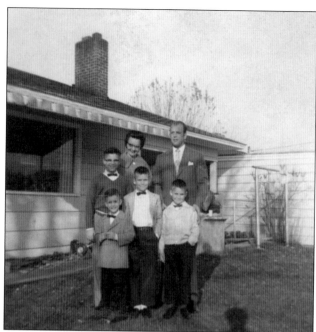

This is a photograph of the Vorous family. Shown are, from left to right, (first row) James Scott Vorous, Greg Vorous, and Mark Vorous; (second row) John Vorous, Joan (mother), and Robert (father). (Courtesy of John Vorous.)

Opal Lintula poses with two of her granddaughters in front of Lintula's house on Fifth Street in Clarkston, Washington. The girls are Lynn (left) and Gay Paris. It was rare for snow to come to the valley, but there is a small amount on the ground here. (Courtesy of Bill Lintula.)

This 1965 photograph shows Robert Lintula inside his house at 1206 Fifth Street in Clarkston on Christmas Day. The silver tree with the decorative balls was made of aluminum and had lights in various colors, which made the tree change color as it revolved. (Courtesy of Bill Lintula.)

This historic photograph shows how Clarkston looked in a long-ago time. The small house at Fifth and Libby Streets was built in 1921. The dirt road and flourishing crops and flowers call to mind how people lived then, when irrigation had finally reached the town. (Courtesy of Asotin County Museum.)

This photograph was taken early on Christmas Day, 1965. Bill Lintula's mother, Opal, is sewing the stuffing into the bird, as she always did. Bill says it was probably about 4:00 a.m., and that she always baked the turkey low and slow. Since stores in those days were closed on Sundays and holidays, family get-togethers were quite an occasion. (Courtesy of Bill Lintula.)

This photograph celebrating Christmas in 1957 shows the Layton family opening their gifts. From left to right, Rick Layton, Rex Layton, and Karen Layton are shown. Other family members are unidentified. It looks like Santa had been good to them. They have a beautiful silver tree, which was the fashion at the time. (Courtesy of Karen Layton McGuire.)

The Lintula family poses at their home on the Clarkston Heights. Shown here from left to right are Alex Lystila, Lusiina Lintula, Bill Lintula, Aina Lintula, and Frank Lintula. After the children grew up and left, the family eventually sold the orchards and moved to town. (Courtesy of Bill Lintula.)

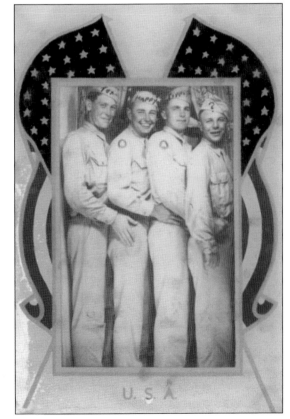

This photograph of four World War II soldiers was taken in 1942 in Killeen, Texas, weeks before they shipped out to Europe. Two of the soldiers married two sisters, Norma and Patricia Way, after the war. The two, Ed Tippett on the left and Jerry Morris, second from the right, raised their families in Clarkston. Ed was Doug Morris's uncle, and Jerry Morris was Doug's dad. (Courtesy of Doug Morris.)

Albert C. "A.C." Vorous was the mayor of Clarkston in the early 1930s. He moved here from Mott, North Dakota. Before that, he lived in Fish Creek, Wisconsin. He died in 1949 and is buried in Vineland Cemetery in Clarkston. A.C. and his son Floyd K. Vorous bought Clarkston Fuel & Feed in the 1920s and changed its name to the Vorous Company. (Courtesy of John Vorous.)

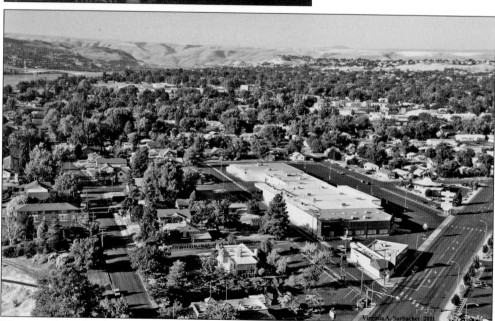

This view from above shows Clarkston, Washington, as it is today. From a small humble beginning to a thriving town with big box stores like Costco and Walmart, it still keeps its small-town feeling. (Courtesy of Virginia Sarbacher, V-n-R Imagery.)

Jennette Jensen (left), the first Miss Clarkston in 1960, crowns her best friend, Eileen Pyle, winner of the 1961 contest. Clarkston had a winner who also won a national contest, in 1976: Lenne Jo Hallgren. The program is now known as Distinguished Young Women: Scholarship, Leadership, Talent. In the early days, it was sponsored by the Clarkston Chamber of Commerce, but it is now an independent organization. The popular America's Junior Miss competition, which Lenne won, began in 1958 in Mobile, Alabama. It was founded by the Junior Chamber of Commerce. From its inception, it has stressed academic achievement, poise, talent in the performing arts, and physical fitness. One of its purposes has always been to award college scholarships. Typically, over 5,000 contestants participate. (Courtesy of Jennette and Tom Hoffman.)

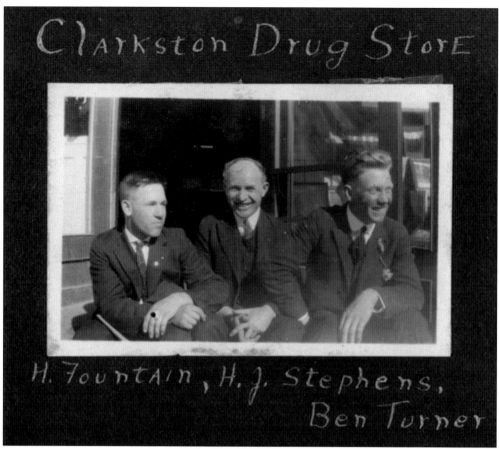

Clarkston Drug Store

H. Fountain, H. J. Stephens, Ben Turner

This is another photograph from the Fountain Collection, belonging to John Vorous. It shows some of the businessmen in the town around 1919. Pictured in front of the Clarkston Drug Store are, from left to right, H. Fountain, H.J. Stephens, and Ben Turner. Clarkston Drug Store was one of the oldest drugstores in the area. (Courtesy of John Vorous, the H. Fountain Collection.)

This photograph shows Bill Lintula (left) and friend Ron Domaskin throwing snowballs in 1958. The photograph was taken at the Lintula home at Fifth and Libby Streets in Clarkston, Washington. With its warm climate, the valley rarely saw snow. (Courtesy of Bill Lintula.)

This is a portrait of the Pike family children taken in 1959. Shown from left to right are (seated) Clarice and Ron; (standing) Darlene, Lloyd, and Marilyn. They lived in Clarkston and went to Charles Francis Adams High School. Family portraits were popular then as now. They used sepia instead of color, which was popular at the time. (Courtesy of Marilyn Pike Wilson.)

This 1952–1953 photograph shows Ed Tippett sitting in the yard of the Lintulas' house on Pound Lane in Clarkston, Washington. Ed is holding two of his children, who are unidentified. There was also another son, Steve Tippett, who was born a couple of years later. Ed was Bill Lintula's uncle by marriage. (Courtesy of Bill Lintula.)

This is the Skyway Motel in Clarkston, Washington. Motels became very popular in the 1950s. They were always a hit with children, as they often had pools and other attractions. Some of the era's motels have been torn down and replaced. At one time, it was very impressive to stay at a motel. (Author's collection.)

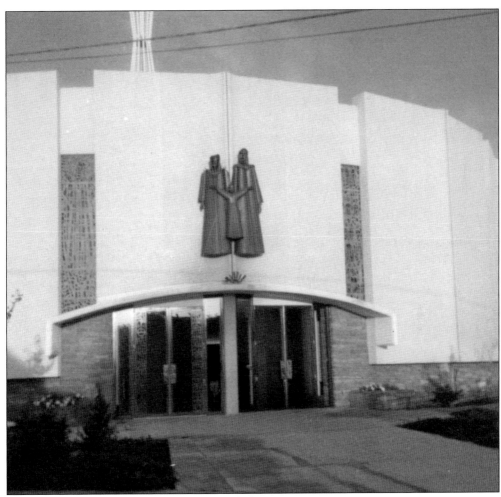

This photograph shows the Holy Family Catholic Church in Clarkston, Washington. It was a long wait for the Catholics to finally get their own church. Many members of the church worked long and hard to achieve this dream. This replaced the original church. (Courtesy of Asotin County Museum.)

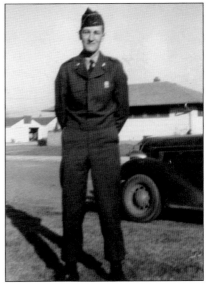

Looking like he just got back from the service, Bill Lintula's older brother, Lyle Lintula, looks happy to be home on leave from boot camp. At that time, it was required that men who were drafted go into the military for two years. This photograph was taken in 1954. (Courtesy of Bill Lintula.)

Taken in 1959, this is the last known picture of Clarkston before the sidewalks were torn up and the city took out the old tying posts for horses. Hogan's Tavern is pictured on the left in the background. From left to right are Bill Jones Sr., Warren E. Smith, Warren W. Smith, and Tim Smith. The horses were tied up to sidewalk horse-tying rings. (Courtesy of Doug Renggli.)

This photograph shows another view of the beautiful landmark named Swallows Nest Rock. It is in the upper center of the photograph and towers over the Snake River, which separates Washington and Idaho. The view is from the upper part of what is now Clemans Addition. (Courtesy of Brad Stinson.)